British and Foreign

FLOWERING PLANTS

Anna Atkins

GETTY PUBLICATIONS, LOS ANGELES

Photographer

Naturalist

Innovator

COREY KELLER

Note to the Reader

About the names: Historical figures are most often referred to by their last names; however, for this book, the author has decided to refer to Anna Atkins, her family, and her friends on a first-name basis to avoid confusion. Anna Atkins is only referred to by her last name when she's mentioned in context with historical figures who aren't members of her family.

Contents

Introduction 7

Chapter One 13
The "A" Is for Anna

Chapter Two 37
"Impressions of the Plants Themselves"

Chapter Three 71
The Art of Science

Epilogue 93

Glossary 100

Notes 102

Bibliography 104

Acknowledgments 106

Illustration Credits 107

Index 108

Cystoseira granulata.

Introduction

On a sunny day in 1843, Anna Atkins carefully removed the sheet of glass that held a spray of seaweed flattened to a sheet of paper. She picked up the fragile piece of *Cystoseira granulata*, gathered from a tide pool on the southern shore of England, and gently placed it in her book of dried seaweed specimens to use again later. The unpredictable English weather had cooperated that day. Just a few minutes' exposure in the bright sunshine had produced a chemical reaction, turning the sheet of paper, which Anna had painted with a light-sensitive solution, from yellow green to a dark greenish brown. Where the seaweed had blocked the sun's rays, however, a pale outline of the long stems and delicate fronds remained.

She plunged the paper under a stream of cool, clean water. As the unexposed chemicals washed away, the print turned a vivid cyan blue. The white shape left by the seaweed's shadow stood out sharply against the bright background. It seemed to float there, as if still in the depths of the sea from which it came. Anna pulled the cyanotype print from the water and set it aside to dry.

By October of that year, she had made cyanotype images of seven more kinds of British seaweed. She now had enough copies of each to sew them by hand into booklets, which she bound with bright blue paper made by the same chemical process. Along with the seaweed pictures, she included a short description of her project and a loving dedication to her father. She sent the booklets off to a circle of what she modestly called "botanical friends"—a group of plant lovers that included Sir John Herschel, Britain's most famous scientist and the inventor of the photographic printing process she had just employed.

This was only the first step in what would turn out to be a decade-long project, but it was a truly momentous one. Anna had produced the first section of the very first book illustrated with photographs: *Photographs of British Algae: Cyanotype Impressions*.

Cystoseira granulata from *Photographs of British Algae: Cyanotype Impressions* (Vol. I) by Anna Atkins, 1843

The Mysterious A. A.

Nearly fifty years later, in 1889, a Scottish chemist and book collector named William Lang Jr. organized an exhibition at the Philosophical Society of Glasgow. The highlight was his newly purchased copy of a large album of botanical cyanotypes. The beautiful book, titled *Photographs of British Algae: Cyanotype Impressions*, was bound in two heavy volumes and contained photographic images of more than four hundred types of British seaweed, all rendered in bright blue and white and labeled with their scientific names. Lang had been obsessively searching for the book ever since he read a description of it in an article by the English inventor of photography, William Henry Fox Talbot. Almost in passing, Talbot had mentioned that "a lady, some years ago, photographed the entire series of British sea-weeds, and most kindly and liberally distributed the copies to persons interested in botany and photography."

The remark sparked Lang's curiosity, but as Talbot did not include the name of the "lady" photographer, it took him twenty years to find her book. When he finally held a copy in his hands, he marveled at the labor that had gone into its production. However, he was frustrated to discover that its introduction was simply signed "A. A." With no further clues to the author's identity, he concluded that the initials must stand for "Anonymous Amateur." He knew only that a woman had assembled the book, so he assumed it was unlikely she had been a professional. Perhaps she wished to keep her name concealed, but he hoped that readers of the *British Journal of Photography* might be able to shed some light on the mysterious "authoress." He wrote a brief article recounting his quest to find the book, including an admiring description of its contents. He concluded with this request: "We leave it to the readers of the *Journal* to see if further information be not available."

Luckily, one such reader was a curator in the Department of Botany at the Natural History Museum in London, which also owned a copy of *Photographs of British Algae*. The "A. A." in question, he wrote, was a "Mrs. Atkins, who lived for many years at Halstead Park, Kent, and died there in June, 1871. She was the daughter of John George Children, Assistant Librarian . . . at the British Museum from 1816–1839."

This story of how the identity of Anna Atkins, maker of the first photographically illustrated book, was almost forgotten is a curious episode in the history of photography. But her close call with obscurity reflects the way women's stories have been routinely left out of those histories. For more than a century, scholars considered Talbot's book, *The Pencil of Nature* (1844–46), to be the first book illustrated with photographs. Since Talbot was a well-known public figure—the inventor of photography on paper and a prominent member of British scientific circles—it is not surprising that his attempt at photographic publishing received more acclaim. We now know, however, that Atkins's work on *Photographs of British Algae* preceded his by several months.

The ways the two books were received, both in their own time and by historians, were in part a result of the very different ways they were produced. These differences also echo how men and women were able or expected to behave in the world. To publish *The Pencil of Nature*, Talbot applied the new technique of the assembly line—invented during the Industrial Revolution—to the even

newer medium of photography. This strategy allowed him to make nearly four hundred copies of his book. Atkins, on the other hand, produced her book at home, by hand. Though we can't be sure exactly how many copies she made, there were certainly fewer than twenty. Moreover, Talbot advertised and sold his book to any buyer interested; Atkins gave hers freely to a group of fellow botany lovers (who would have known that "A. A." stood for "Anna Atkins"). However, in a twist of fate, the process Atkins used to make her photographic prints proved to be far more permanent than Talbot's. While many of his photographs faded during his lifetime (to Talbot's great frustration), Atkins's cyanotypes are still as vivid and beautiful as when she first made them, nearly two hundred years ago.

"By a Lady"

Though today Anna Atkins's place in the history of photography may be secure, many of the details of her life are still a mystery. How is it possible that we can know so little about this imaginative woman? We get a few glimpses of her daily life from a book she wrote to commemorate her beloved father, the accomplished scientist John George Children. This memoir, meant only for close friends, celebrates his lifelong devotion to science (as well as his enthusiasm for putting his feelings into verse). Anna plays only a minor role, but the book paints a vivid picture of the important place of science in her home. It also shows us that Anna and her father enjoyed a close, loving relationship. His ardent support of her interest in science and photography would prove a powerful factor in her success. Through his position in the scientific community, Anna was exposed to the most cutting-edge ideas of the nineteenth century. And as a result of his encouragement of her own work, she was in a unique position among women to contribute to these ideas.

Beyond this tribute to her father, Anna wrote little else. (It was once suspected that she also authored several novels, but this claim has since been debunked.) If she kept a journal with concrete information about her daily life or her thoughts and feelings, it has not survived, and though she no doubt wrote many letters to her friends and relatives, only a handful have been found. What she did leave behind is an extraordinary body of early experiments in photography, evidence of an inventive mind and outsized ambition. The historians who managed to piece together her story had to perform exhaustive detective work.

That Anna left little written trace is not so unusual for women of the Victorian era. During this period, which roughly corresponds to Queen Victoria's reign (1837–1901) but is often said to reach from 1820 to about 1914, life in Britain was strictly divided along gender lines. Today it is almost impossible to imagine how much of a Victorian woman's life was dictated by her gender. Men were expected to participate in the public domains of work, science, and politics, while women were confined to the private arenas of the home and family. This division also dictated the way women's histories have been told. While a man's journals, notebooks, or letters might have been preserved for future generations (Talbot's letters, for example, have been fully digitized and have an entire website dedicated to them), women's diaries and letters were thought of as private documents.

A great deal of what we know about the texture of women's lives comes from literature aimed at teaching female readers how to behave politely and morally in society rather than from women's accounts of their own experiences.

There were, of course, women who went against convention and wrote for public audiences, but many did so under masculine pen names. For example, the Brontë sisters (Charlotte, Emily, and Anne) wrote as "the Bell brothers" (Currer, Ellis, and Acton). Other women wrote under the cloak of anonymity; no one knew their true identities. Though Lang's assumption that "A. A." meant "Anonymous Amateur" might sound ridiculous to our modern ears, within the context of nineteenth-century publishing his conclusion was rather logical. Even Jane Austen—a contemporary of Anna's, now celebrated as one of the greatest novelists of her time—never saw her own name in print. Austen's first novel, *Sense and Sensibility*, was published in 1811 as "By a Lady," and her second, *Pride and Prejudice* (1813), was credited to "the author of *Sense and Sensibility*," despite the book's tremendous success. Austen's authorship was not made public until after her death.

Women's contributions to science, though significant, also frequently went unrecognized. For the most part, nineteenth-century women were not permitted to participate in research or join the vibrant societies where scientific knowledge was exchanged. They nonetheless contributed in other meaningful ways—as illustrators, collectors, and educators—often as wives or daughters of scientific men. By habit or on purpose, their names have not always been recorded. As the daughter of a "man of science," Anna was no passive participant but rather an active partner in scientific pursuits. She found ways to make important contributions even while working within the constraints of such gendered social norms.

Writing the history of nineteenth-century women requires a certain amount of creativity. We have to search out new kinds of sources for information. To fully understand Anna Atkins's place within photography and botany, we need to look at the contexts in which she lived, learned, and worked, as well as the audiences she imagined for her pictures. A true history of women's roles in science also demands that we reconsider ideas about which activities "count" as scientific practice. Such stories would help paint a fuller, more nuanced picture of the past and allow a richer understanding of where modern ideas come from. While Anna would hardly recognize the way we make and share photographs in the twenty-first century, her very early experiments in photography helped shape the way we use pictures and think about image-making to this day.

Ceylon from *Cyanotypes of British and Foreign Flowering Plants and Ferns* by Anna Atkins, about 1854

Himanthalia lorea

Chapter One

The "A" Is for Anna

A Family at Ferox Hall

It had been an unusually cold winter that year, and spring was slow in coming. Yet the blustery weather was all but forgotten in the warmth of a "handsome, well-built" home about thirty miles southeast of London when a young couple, John George and Hester Anne Children, welcomed the birth of a baby girl. Anna Children came into the world on March 16, 1799, at a house called Ferox Hall in the town of Tunbridge (now spelled Tonbridge) in Kent, England. This new baby was the fourth generation of Childrens to live at Ferox Hall, though the family could trace its roots in the area all the way back to the 1300s. Her arrival was greeted by her parents and grandfather with great joy.

Himanthalia lorea from *Photographs of British Algae: Cyanotype Impressions* (Vol. I) by Anna Atkins, 1843

Tonbridge—Ferox Hall by F. Cooke, about 1870

The only photographs we have of Anna's childhood home were taken long after she lived there. This picture from about 1870 shows the back of the house, but its three-story brick front is still easily recognizable on Tonbridge's High Street today.

George Children by Archer James Oliver, about 1806

Anna's grandfather, George Children, had this portrait painted when she was a child.

Anna would grow up in an era of unprecedented change, as the Industrial Revolution was transforming daily life in England. Her hometown was a perfect example. Tunbridge was a lively trade center on the Medway River. Before the 1740s, the river had been almost impossible to navigate. The roads were even worse, making it difficult to transport the most basic supplies to the area. But since then, workers had been building a series of locks along the river to make it possible for cargo boats to pass. By the time Anna was born and the century turned, barges carried materials like coal, stone, timber, sugar, wheat, and gunpowder to and from the Tunbridge wharves. Now the residents had access to a wide range of consumer goods, as well as the materials for construction and manufacturing, which completely remodeled the area's economy.

Anna's family benefited from the advances the new century brought. Even within their prospering community, the success of Anna's grandfather, George Children, stood out. A banker and investor (in the company that was responsible for improving the Medway River, among other ventures), he was an active and respected member of society, particularly noted for his gracious home. George had been trained as a lawyer, though he never practiced law. In his spare time, he enjoyed writing poetry and would pass this love of verse on to his son. However, his social and economic status could not protect the family from tragedy. When Anna's father, John George, was just six days old, his mother, Susanna (Anna's grandmother), died as a result of childbirth. In an unusual decision for the time, George chose not to remarry, and he educated his son at home until it was time for John George to enter school. George could not anticipate that history would soon repeat itself for his own son and granddaughter, but his choice would shape their lives in profound ways.

George was devoted to his son and made sure he received an excellent education. John George went to the local school and then a private tutor until the age of fourteen, when he began attending Eton, the prestigious boys' school. As a teenager, he became deeply interested in science, but after Eton he went to Queens' College, Cambridge, intending to prepare for a life in the church. While Cambridge students today pursue many different career paths, for much of its history its graduates went on to positions in the Church of England, which was both the official state church and a powerful political force. Many took jobs as parish priests, who not only tended to a community's spiritual needs but also earned a steady income. John George's father encouraged him in this direction, thinking it wise that, despite the family's wealth, "his son should have some employment." It was during his time at Cambridge that he met Hester Anne Holwell, known as Anna, who was the daughter of a colonel and lived in the next town over with her uncle.

When John George first met Hester Anne, she was "much admired and much beloved—a charming musician, and had a lovely voice which she was accompanying with her harp." John George was smitten, and they soon became engaged. When her guardian died unexpectedly, John George took a break from university so the couple could marry. He and Hester Anne were both only twenty-one when they wed in 1798, and they went to live with George at Ferox Hall. They planned to stay there only until John George could return to school and complete his studies, but before the end of their first year of marriage, Hester Anne gave birth to a daughter. The happy parents named their child Anna, after her mother. But their happiness was short-lived, for once again tragedy struck the Children home.

Anna Children **by unknown artist, about 1800**

Before people could take photos of their loved ones, those who could afford it might hire an artist to paint miniature portraits. These palm-sized (or smaller) paintings were made on paper, parchment, or ivory, as was this one of baby Anna clutching a spray of flowers.

The Industrial Revolution

Even Anna's clothes were an example of the changes that were sweeping England in the late 1700s. For centuries, craftspeople had spun yarn and woven cloth by hand, at home or in small workshops. By the time Anna was born, these goods were made in factories, and by the 1830s, a system of mills was pushing out large quantities of high-quality textiles. New sources of energy fed rows of loud, fast machines, such as the power loom and "spinning jenny," which did the work of eight people at a time. Mill owners could quickly and inexpensively transform the cotton they imported from Britain's colonies into cloth. The growing demand for cotton in England led to the development of other new technologies, including the cotton gin in the United States, which mechanically removed the seeds from cotton at least ten times more efficiently than a person could by hand. New canals, steamships, and steam-powered trains meant that manufacturers could sell their goods all over the British Empire.

The Industrial Revolution not only changed what people wore; it also fundamentally changed how they lived, worked, traveled, and ate. This "revolution" was not an overnight event but a gradual transition, as Britain morphed from a rural society based on farming and craft to an urban, industrialized one dominated by the mass production of manufactured goods. This shift peaked during Anna's lifetime.

Mass production—the change from making goods by hand, one at a time, to making many identical things at once with the help of machines—depended not only on new technology and sources of energy but also on the standardization of parts. This included items as tiny as a screw. For example, before the 1860s, screws were designed and produced individually. They were unique to each manufacturer. The move to a system of standardized, identically engineered screws meant that parts were now interchangeable across Britain. Goods—and the machines that cranked them out—could now be mass-produced. Factories pumped out shoes, tools, tableware, and toys that used to be expensive and made by hand. The growing middle class, who now had extra money to spend, took great pride in demonstrating their new status by purchasing items that were previously available only to the wealthy.

The new machines that powered the Industrial Revolution needed fuel—and a lot of it. Luckily, Britain was rich in an important mineral: coal. Where other countries still depended on charcoal (burnt

Factory Interior by unknown artist, 1871

wood) for fuel, British engineers found ways to use the more intense heat generated by coal to fuel engines and transform Britain's large deposits of iron ore into iron and steel. As the skies filled with clouds of black smoke from their enormous furnaces, iron and steel mills rapidly produced the materials to manufacture even more machines, build a network of bridges and railroad tracks, and construct large buildings.

As more people went to work in factories, the population migrated from the countryside to urban areas. By 1851, Britons were startled to read in the census that half of the population now lived in towns or cities. By the end of the century, the shift was even more dramatic: four out of five people were town or city dwellers. With fewer people working on farms, Britain faced a new problem: How would it feed its growing urban population? People had to invent new methods of production and storage, ranging from the use of chemical fertilizers in agriculture to the development of canned and shelf-stable food.

Unfortunately, the benefits of the Industrial Revolution were not distributed evenly. For the laboring poor especially, city life and factory work were dirty, stressful, and often extremely dangerous. Women, too, went to work in the factories, though they were paid less than men. Even their children worked long days in the mills. Though reform was slow, these terrible conditions eventually prompted improvements in sanitation and public health that helped all city residents.

John George Children by Benjamin Rawlinson Faulkner, 1826

This formal portrait of Anna's father, John George Children, was made after he had established himself as a respected scientist. The year it was painted, he was elected to lead Britain's most prestigious scientific society.

A Father's Love

Childbirth was a dangerous business in the 1800s. It was not uncommon for a mother, an infant, or both to die during the birth or afterward. In the days before antibiotics—even before the theory that infections might be caused by germs had been put forward—tens of thousands of English families lost sisters, wives, and mothers to childbirth. Like so many other women, Hester Anne became ill not long after giving birth. After a period at home, she was sent to the seaside town of Hastings to recover. Anna tells us (in the memoir she wrote many years later) that her mother endured this "period of sickness by pursuing some of her accustomed employments—reading, keeping a journal, and even drawing a little, and working [embroidering] for her babe, happily unconscious of the loss awaiting it."

Hester Anne spent nearly two years in Hastings but never returned home. We don't know if Anna got to see her mother during this prolonged separation, but sadly, the two were never reunited. Hester Anne died in Hastings at the age of twenty-three. The death of Anna's mother, like that of her grandmother years before, was not only tragic; it also had a major influence on the course of Anna's childhood, for it left her in the unusual position of being a young girl raised primarily by men.

John George had planned to return to university after his marriage, but his wife's death plunged him into grief. He spent the next two years traveling across Europe and the United States, leaving baby Anna with her grandfather. Although she had an unusually involved grandfather and father, Anna spent her early years in the nursery in the care of a household servant, as was typical in upper-class homes. In those days, it was customary for parents and their young children to live rather

separate lives, spending only an hour or two together each day. Without her mother, and with her father abroad, Anna's nurse must have played an especially important role in her childhood. As Anna grew older, this role would have been taken over by a governess. Though Anna surely missed her father during his long trip, she was well looked after.

When John George returned home in 1802, his plans for a religious career were once again delayed, this time by England's preparations for war with France. A patriotic man, he joined the militia, but his health forced him to quit the armed forces three years later. (He had been described as "delicate" at birth, and he would be unwell for much of his life.) He abandoned his pursuit of the church and turned his full attention to his passion for science, and to his six-year-old daughter.

For the rest of their lives, Anna and her father were nearly inseparable. Their close relationship was unusual. In those days, many men who had lost their wives to childbirth sent their children—particularly daughters—to be brought up by relatives if they did not remarry. Anna's father, however, chose to raise his daughter himself with the help of his own father. Although he did remarry when Anna was about ten, he was terribly unlucky a second time. His new wife, Caroline Wise, died after they had been married only a year, along with her stillborn child. Once again, John George and Anna were on their own.

"Dear as a Sister"

The Children family was not entirely alone at Ferox Hall for long, however, as Anna's father soon found himself raising another girl who had lost her mother. Though Anna had no biological siblings, her new friend, Anne Austen, became as close as one could get. We know even less about the details of Anne's biography than we do about Anna's. She was born just four months after Anna, about twenty miles southeast of the Childrens' home. (Anne was also a second cousin to the novelist Jane Austen, but there is little indication that their families interacted.) Her father, who was John George's old friend, was a major in the military and was frequently deployed abroad. Her mother died when Anne was about eleven.

Young Anne spent so much time in the Children household that she came to see John George as a kind of surrogate father. He in turn considered her "almost as a daughter," and "to his real daughter" she was "dear as a sister." Though Anne did not live with the Childrens permanently, the two girls became the closest of friends. They remained so through all the successes and challenges of their adult lives, parted only by Anne's death half a century later.

John George's decision to keep Anna at home with him played a key role in shaping Anna's future accomplishments in photography. Feminist historians have observed that although science was primarily a male domain throughout the Victorian era, a number of women found ways to enter the field despite the barriers their gender posed. Like Anna, many of these remarkable women were motherless daughters of scientific men who chose to nurture their daughters' interests and education beyond the scope of what was typically expected of girls.

Surrounded by Men of Science

Anna grew up in a beehive of scientific activity. Thanks to her grandfather's wealth, her father did not need to earn a living. Having abandoned his plans for a religious life, he turned his attention to constructing a state-of-the-art laboratory at Ferox Hall.

John George was particularly interested in a thrilling new invention: the battery. Italian physicist Alessandro Volta had discovered a way to chemically produce, store, and distribute energy. Volta's battery (also called a "pile" for the way it was constructed) made it possible to reliably produce and harness electricity. This had enormous implications for science and industry, and it created great excitement in Britain. John George was most interested in the use of electric currents to break down minerals and discover their components, a field known as electrochemistry. Though Anna did not yet know it, this technology would have important implications for her own future projects: electrochemistry offered a new way to manufacture the chemicals that she would later use to produce photographs.

Ferox Hall's buzzing, well-equipped lab drew the attention of the scientific community, and the Children family frequently hosted the men who came to work with John George on his experiments. Anna's grandfather was known for his hospitality, and his friendly conversation offered these researchers a much-needed break after days spent in "severe study." Dinners were lively affairs, as the men hashed out their theories and debated ideas. In 1807, when Anna was eight, John George was given a great honor: he was elected as a member of the Royal Society, the oldest and most prestigious scholarly association in Britain. This put him in contact with the most influential men of science and gave him direct access to the most cutting-edge ideas of the day.

Soon after he joined the society, a large group of distinguished fellow members came to see his lab and learn about his work. Among them was the ambitious, up-and-coming young chemist Humphry Davy, who was responsible for numerous important discoveries, including the elements sodium and potassium. Davy had been experimenting with Volta's piles, and soon he and John George were working together with large batteries for days at a time in Anna's home. The two men also undertook extensive investigations into explosives. It was not an activity for the fainthearted! One of their experiments resulted in Davy injuring his eye and finger badly enough that he had to stay at Ferox Hall for several days to recuperate. Anna could not help but absorb the excitement that surrounded her. Her childhood and teenage years must have been full of tales of experimental success and failure. By the time she was fourteen, her father was widely celebrated for his efforts in constructing ever-larger batteries, including the "greatest galvanic battery" ever made.

Anna not only enjoyed a close-up view of her father's work, but over the course of her lifetime she also witnessed important changes in scientific practice and thinking. At the beginning of the 1800s, the serious pursuit of scientific knowledge did not require specialized education. Many of the most innovative ideas were developed by well-educated, curious, passionate, and wealthy amateurs like her father. These men were often referred to as "gentlemen scholars" or "men of science." But the practice of science was moving away from a long tradition of "natural philosophy," a broad approach that encompassed the observation of all natural phenomena. It was heading toward a different model based on rigorous,

repeatable experiments. We now call this approach the "scientific method." Science was also becoming more of a profession, and trained specialists who focused on narrow fields of study would soon replace generally educated people who took a broad interest in scientific things. Still, the term "scientist" did not even enter the English vocabulary until 1834, and John George counts among the ranks of dedicated amateurs who contributed in immeasurable ways to the rapidly expanding body of scientific knowledge in the early nineteenth century.

A Diverting Excursion

Life in the Children family was not devoted only to the pursuit of science. The family occasionally ventured into London to enjoy its entertainments. One such excursion in 1814, when Anna was about fifteen, prompted her father to pen a series of lighthearted poems to and from her "very favourite and faithful pug-dog," who remained at home. This one gives us a glimpse into what a young woman might look forward to in London:

> *But not long away*
> *Your mistress will stay,*
> *(And I'm sure you'll not grudge me a week);*
> *I must have some gadding,*
> *I must see Aladdin,*
> *And dear Catalani hear squeak.*
> *At the grand Exhibitions,*
> *Royal Academicians,*
> *Water-colours and Sir Joshua's;*
> *I must have a look*
> *And I never can brook*
> *Not to see the new panoramas.*

Two hundred years later, the poem's references seem old-fashioned and almost impossible to understand. A little decoding, however, reveals that the Childrens were up to speed on current attractions and looking forward to some social time ("gadding") in "town." Their itinerary was jam-packed with activities: a trip to Covent Garden to watch the hugely successful play *Aladdin*, or perhaps a concert by the world-famous soprano Angelica Catalani (whose beautiful singing inspired even Napoleon to declare his love) at the King's Theatre. Anna, who was learning to draw, would have enjoyed the exhibitions at the Royal Academy, where the works of contemporary painters John Constable, J. M. W. Turner, and Henry Fuseli were on display. And the Childrens no doubt visited the Leicester Square panorama, where they would have taken in a spectacular depiction of Lord Wellington's recent victory over the French in the Battle of Vitoria. Panoramas—large, circular rooms for viewing enormous paintings hung in the round—were a popular form of entertainment. Anna and John George would have stood on a raised platform in the center and immersed themselves in the dramatic scenes surrounding them. Special effects such as lighting and even sound might have enhanced their experience.

Section of the Rotonda, Leicester Square by unknown artist, 1801

This cross section shows the inner workings of the Leicester Square panorama. Visitors emerged from a dark corridor into the rotonda (a large, round room), where they stood surrounded by a painting several hundred feet long. This particular building offered two different immersive experiences dramatically illuminated by large skylights.

Cities like London changed visibly during Anna's lifetime and were full of spectacles designed to appeal to the eye. These included traditional attractions, like the theater, opera, and art galleries, as well as new forms of display, including department stores (whose enormous windows were made possible by new techniques of manufacturing glass), wax museums, and scientific demonstrations. Anna's time in London, so different from country life in Kent, must have provided an exciting, overwhelming, and stimulating change of scene.

Beyond "Accomplished"

Clearly Anna's family valued learning, but we don't know much about her formal education. Like most girls of her social and economic class, she briefly attended boarding school, but she seems to have received the majority of her schooling at home, in the care of "her kind governess and good friend Miss [Anne] Bullen." Like so much else at that time, education was very different for boys than it was for girls. The chief purpose of girls' instruction was to turn them into marriageable young women and prepare them for their future duties as wives. This would include educating their children and managing a household and the domestic staff needed to run it. Girls learned reading, writing, geography, and French or Italian, as well as needlework, drawing, watercolors, and music. These skills were known as "accomplishments." However, while they were considered highly desirable qualities in an upper-class wife, they were not intended to foster a career.

Anna Children by unknown artist, about 1820

This delicate pencil drawing is one of the only images we have of Anna as a young woman. Given her talent as an artist, it's possible that it is a self-portrait. It was made when she was about twenty-one years old.

Anna seems to have particularly enjoyed drawing, and the few examples of her work that survive demonstrate that she not only was competent but also had real talent. The family—George, John George, and Anna, along with Miss Bullen—occasionally traveled as a group, and one place they went was to the Isle of Wight. Anna often sketched the sights along the way, and her early drawings are finely rendered and delicate. She made them for pleasure as a girl, but she would find her artistic skills unexpectedly handy in the years to come. As she grew older, she used her sketches as the basis for vivid watercolor paintings and even lithographic prints (made from a drawing on a stone or metal plate).

University education was entirely off-limits to girls until well into the second half of the nineteenth century. Nor did girls typically study Latin, an essential skill in several scientific disciplines—especially botany, which used Latin names to classify plants. Learning Latin was a rite of passage in boys' education but thought to be unnecessary for girls' lives.

Anna's education, however, went well beyond the traditional feminine curriculum. Her access to formal instruction in science would have been limited at any school, but at home her devoted father gave her lessons on the subject, which he designed just for her. When she was about fifteen, he organized a series of scientific lectures on chemistry for "his daughter and a few intimate friends" at Ferox Hall. These friends no doubt included Miss Bullen. They may have also included Anne Austen, who probably benefited from Anna's unusual education. Since she was frequently staying with the Childrens at this time, it is entirely conceivable that she took part in these sessions.

The girls watched and listened attentively to twenty-one lectures in all. Anna's father enlivened his talks with engaging, hands-on, "and almost invariably successful" experiments. He taught the group about the elements, the laws that govern natural phenomena, and the principles of scientific experiment itself. They learned about the density of water and why the seas don't ever freeze over. His lessons were intended to "improve [Anna's] understanding" and "enlarge her heart." Though today science and religion are often understood as representing different—or even opposing—belief systems, in the early nineteenth century the study of science and God were one and the same. By educating his daughter in scientific principles, John George wanted to expand both her mind and her spirit and share his belief that "some acquaintance with Natural Philosophy tends to an extension of liberal sentiments, and to exalt our ideas, both of the Great Author of all things, and of his creature, man."

22 Chapter One

Whatever gaps there may have been in her formal schooling, young Anna had a front-row seat to the most cutting-edge discoveries of her day. She not only learned directly from her loving father; she also got to meet many of Britain's most important scientists who were radically changing the way people understood the world. Her father's network of scientific friends, along with her unusual opportunities to learn firsthand, gave her a window into these transformative ideas that very few women at that time could claim.

Financial Ruin

When Anna was seventeen, her life changed dramatically. The Children family went bankrupt. The Tunbridge Bank (of which her grandfather was a founding partner) had been in financial trouble for several years, but now it was completely out of funds. To make things worse, John George's new gunpowder business went under that same year. They were forced to sell Ferox Hall, and while her father looked for a new place for the family to live, her grandfather was sent to a convalescent home to recover his health. The strain from both physical illness and emotional stress had taken a toll on him.

Parted from her father and grandfather, Anna went to live for several months with longtime family friends: her grandfather's brother-in-law, the Reverend J. T. Jordan; his wife; and their niece, Margaret Jordan. Their home, though welcoming and lovely, was a long journey from either Tunbridge or London. Though her father wrote to her regularly, how awful it must have been to lose the comfort and familiarity of her home and to see her beloved family in such distress all at once.

Luckily, Anna was able to find some stability with the Jordans. Like her father, the reverend was passionate about science, and Margaret provided loving friendship to Anna when she most needed it. In fact, Anna's great-uncle played a far greater role in her future happiness than he would ever know. Through him, Anna and her father made a new acquaintance, a certain John Pelly Atkins, who was one of Reverend Jordan's favorite students. Ten years older than Anna, he was the only surviving son of a well-off businessman. He would come to have a much stronger connection to Anna and her father in the future.

The dramatic reversal of the family's fortunes also meant big changes for Anna's father. For the first time in his life, he had to find a job and earn a living. His well-connected friends attempted to help. Humphry Davy tried to find him a scientific position at the British Museum, but his efforts were unsuccessful.

On the Walls at Chester—from a Sketch by A. A. by Anna Atkins, 1820s–1830s

This watercolor painting is based on a sketch Anna made while visiting the ruins of an ancient Roman fortress in the English town of Chester.

Queen Victoria by Bryan Edward Duppa, 1854

Queen Victoria married Prince Albert in 1840, just a year after the invention of photography. Though they were public figures, most of the portraits they commissioned were made for private use. Here, Victoria is pictured not as a queen but as a devoted wife holding a framed photograph of her beloved husband.

Into the Victorian Era

Beyond the scientific, economic, and technological changes Anna experienced, there were major political and cultural changes as well. Although today the king or queen of England plays a mostly ceremonial role, during Anna's lifetime the person sitting on the throne made a great deal of difference in day-to-day life.

As a child and young adult, Anna lived in the period known as the Regency, which began in 1811 with the Prince of Wales taking over for his mentally ill father, King George III. (The "mad" king was memorably caricatured in the 2015 musical *Hamilton*.) During King George IV's reign, war with Napoleon and a series of crop failures meant that Britain's economy was often unstable. The aristocracy grew richer while the living conditions of the working classes declined, particularly as the Industrial Revolution brought an end to their traditional ways of earning a living.

King George IV loved parties and pageantry and was passionate about the arts. Art, architecture, literature, and music flourished, producing at least one innovation still with us today: the novel. Readers devoured the romantic but tortured courtship between Elizabeth Bennet and Mr. Darcy in Jane Austen's *Pride and Prejudice* and admired (or criticized) the way her characters negotiated the complex social rules of the ballroom.

When a young queen ascended to the throne, it marked the beginning of a new era. Only eighteen years old, Victoria was crowned in 1837, and her long, record-breaking reign lasted until 1901. With the partnership of her husband, Prince Albert, Queen Victoria ruled over one of the most transformative periods in British history.

For centuries, most people had never traveled more than a few miles from home. During the Victorian era, railroads crisscrossed England, connecting London to the industrial cities of the north as well as to the seaside, while steamships traversed the Atlantic at record speeds. People bridged distances in other new ways: the electric telegraph and, later, the telephone accelerated communication, while the "penny post" made mailing a letter affordable for everyone. Victoria and (especially) Albert were early adopters of many of the new technologies. They installed a telegraph line and later electricity at their summer home on the Isle of Wight, as well as circulating hot water, a telephone, and an elevator. And both of them were captivated by the invention of photography in 1839. They sat for numerous formal portraits and hired photographers to document their private family life at home. They also actively collected photography and became patrons of the Photographic Society.

The advances in engineering were matched by new knowledge in medicine and science. The discovery that germs (and not "bad air") made people sick, for example, led to changes in sanitation and the treatment of disease. The study of fossils revealed that the world was much older than Bible stories described, just as theories of evolution profoundly reshaped people's understanding of how the natural world worked. Changes in attitudes and policies around education made these ideas accessible to many more people. By the end of Victoria's reign, school was mandatory for all children, not just a luxury for the well-to-do. Literacy rates shot up across the nation, and a growing population of readers avidly consumed both novels and newspapers.

Victoria ruled over the largest empire in the world, reaching from the Caribbean to Oceania. From 1820 to 1870, Britain expanded eastward, gaining resources, wealth, and political power with each new colony. It was also an era of violence, as colonial subjects in India, China, and the Caribbean fought back against British rule. Though slavery was abolished across the empire before Victoria took the throne, the British maintained military, political, and economic control over millions of people of color, and the country profited from their labor and trade.

The quality of Victorian life was very much shaped by economic class as well as gender. In one of the most famous lines from literature, Charles Dickens described the disparities in his 1859 novel *A Tale of Two Cities*: "It was the best of times, it was the worst of times, it was the age of wisdom, it was the age of foolishness, … it was the spring of hope, it was the winter of despair." Three-quarters of the population were considered working class, and many lived in workhouses that were no better than prisons. The upper class, the smallest in number, owned most of the land and held most of the political power. However, the rise of industrialization also helped create a new middle class, mostly urban manufacturers, merchants, and other salaried professionals with disposable income. This led to important shifts in the power structure: middle-class men got the right to vote in 1832, and before the end of the century, working-class men did too. (Most women did not get the vote until 1928.) As the influence of the middle class spread, so did their values of hard work, self-reliance, the importance of family, and Christian morality. As a result, traditional ideas about men's and women's different roles in public and domestic life hardened into a strict code of behavior.

In the end, another influential friend, Lord Camden, secured Anna's father a place as a librarian in the museum's Antiquities Department, though he had no expertise (or particular interest) in the relics of ancient times. He was even more indebted to another family friend who lent the Childrens a London home where John George, Anna, and George could live comfortably, together again at last. The family managed a little traveling to visit relatives and spent many of their evenings at home, with John George reading passages from Shakespeare or the Bible aloud.

Despite the change and upset, Anna found opportunities to continue and supplement her education. When she was eighteen, she purchased a membership to the Royal Institution in London. Founded in 1799, the Royal Institution (not to be confused with the exclusive, all-male Royal Society, of which her father was a member) was a site for groundbreaking scientific research. It also had a commitment to public education, and in 1810 it began offering lectures to members. Anna and Miss Bullen were able to attend lively talks given by eminent chemists, including Davy, who directed the laboratory there until 1821. Davy became something of a public celebrity for his engaging and theatrical (occasionally explosive) demonstrations, and for his particular appeal to female audience members, who famously found him both charming and handsome. When he stepped down, his former lab assistant Michael Faraday took over the lecture series. Faraday became even more renowned than Davy (much to his mentor's annoyance). His work in the new field of electromagnetism enabled him to invent the electric motor. No doubt Anna and Miss Bullen attended his talks as well, once again learning about novel ideas from the most prominent scientists, and perhaps enjoying a welcome distraction from the major upheavals of life at home.

One last terrible event would befall the Children family before this sad chapter in their lives was over. In August of 1818, Anna's grandfather died. George had never fully recovered from the shock to his health over the failure of the Tunbridge Bank. Anna and John George buried him in the cemetery of his beloved hometown. Despite the unfortunate circumstances that had caused him to move away, the residents of Tunbridge came out in large numbers to honor his memory and his contributions to the town.

Chemical Lectures by Thomas Rowlandson, about 1820

In this image, the artist shows the chemist Humphry Davy as a dynamic lecturer who could draw a lively crowd to the Royal Institution. Brightly dressed men and women watch Davy (as well as one another) excitedly as he performs a scientific demonstration.

The Waterloo Elm by
Anna Children, 1818

The Waterloo Elm

In addition to science, the Childrens (especially John George) were interested in British history and politics. Shortly after the death of her grandfather in 1818, Anna, John George, and a cousin traveled to the site of the legendary victory of the Duke of Wellington over the French army at Waterloo in Belgium. The Battle of Waterloo ended Napoleon's decade-long rampage across Europe, and Wellington's victory was a source of great pride for patriotic John George, as it was for many British people.

A large elm tree still dominated the field where Wellington had made his camp, but in the three years since the battle, thousands of visitors had damaged the once-imposing tree by taking pieces as souvenirs. Anna sat down to sketch the remains of the elm. As she drew, her father learned that the timing of their visit was lucky: the tree, in danger of falling, was set to be cut down and removed the very next day. He purchased what remained of it right then and there and had the wood sent back to England.

John George commissioned the famous furniture maker Thomas Chippendale to turn a portion of the wood into an elaborately carved chair as a gift for the king, which can still be viewed at Windsor Castle today. The rest of the tree was dispersed among friends, donated to the British Museum, and turned into a cabinet for John George's collections as well as a second chair, which was given to Wellington himself. When the Duke of Wellington died in 1852, Anna's mournful drawing of the battered but majestic tree was published in *The Illustrated London News*, along with an account of their visit to Waterloo that her father had written in 1818.

A New Chapter

The family seemed to regain some stability when Anna was twenty. Her father had married for a third time, to Elizabeth (Eliza) Towers. Anna's grandfather had introduced the two, and John George and Eliza wed less than two years after his death. Eliza had no children of her own, and although Anna was already an adult, her new stepmother cared for her happiness and well-being as if she were her own child. Anna was delighted, both for her father and for herself, and she welcomed Eliza to their family, noting that she and her stepmother enjoyed an unusually "strong mutual regard and affection."

The three of them at first lived at Eliza's house in Kensington, but John George found it too far from his work. They moved to Russell Square, just adjacent to the British Museum, until they could move into apartments within the museum itself a few years later. John George, a book lover, was especially pleased to be living so close to the museum's splendid library. However, life in polluted London did not suit him, and he found it necessary to spend part of his time in the country. He had never been in robust health, and the dirty air of a crowded city fueled by coal irritated his lungs.

After six years in antiquities, Anna's father was transferred to the Department of Natural History and Modern Curiosities, where he was put in charge of zoology, the branch of biology that deals with the classification of animals. Though this was a scientific subject (unlike his previous assignment), it still was not one in which he had any particular interest or knowledge. Ever inquisitive, he set about educating himself in his new field. He gave himself the task of sorting its large collection of seashells. He also decided to translate the 1799 text *Genera of Shells*, by a French naturalist named Jean-Baptiste Lamarck, into English. To make Lamarck's ideas clear to his readers, however, he would need Anna's help.

Lamarck's work was an important challenge to the existing system of categorizing the animal kingdom. Sorting nature into categories, or taxonomy, was the main focus of nineteenth-century natural historians. But organizing the enormous variety of the earth's plants and animals into a comprehensible system was an overwhelming task. People could not even agree on what categories should be used. One of the most important questions they asked was whether these classifications were natural or whether people should determine them according to a formal system.

The most widely used system for classifying and identifying all animals and plants was that of the Swedish botanist Carl Linnaeus. (We still use this system today, which gives organisms a two-part name determined by their genus and species.) The Linnaean system grouped animals together based on external similarities, but all animals did not fit neatly into this scheme. What about the creatures whose defining characteristic was the lack of an internal backbone? Linnaeus lumped all such creatures under the label "worms," and they were not paid much attention. Lamarck, on the other hand, gave these poorly understood animals a new name: invertebrates. *Genera of Shells* was his attempt to study and sort shell-bearing invertebrates, or mollusks, into categories. ("Genera" is the plural form of the word "genus.")

The interest of Lamarck and others in shells (as well as fossils) was partly motivated by a new understanding that nature was neither fixed nor permanent but undergoing slow and constant change over time. Lamarck was one of the first scientists to formulate a theory of evolution to try to explain such changes, even though not all of his ideas would hold up over time. As evidence of evolution

Drawings for *Lamarck's Genera of Shells* by Anna Children, 1823

rapidly accumulated, people were forced to reconsider long-standing scientific ideas and deeply held religious beliefs about how the world was formed.

Drawing on Anna's Talents

John George knew it would be hard for most readers to distinguish the identifying details of the shells Lamarck described at length without seeing them, so he enlisted his daughter and her talent for drawing to illustrate his translation of *Genera of Shells*. Anna took up her pencil and began to produce 256 meticulously executed drawings and watercolors of the shells. Each drawing had to correspond exactly to the specimen she tried to represent. John George surely would have given his daughter instruction about which features to highlight in order to accurately correspond to and enhance the description in the book. Anna may have used the museum's specimens as her model; she may have also referred to books in her library, including a personal copy of Samuel Brookes's *An Introduction to the Study of Conchology: Including Observations on the Linnaean Genera, and on the Arrangement of M. Lamarck* (1815), for guidance or inspiration. She must have drawn for weeks, carefully and accurately recording every pertinent detail. Both delicate and precise, her renderings show the shells against a blank background with no extra information to distract the eye. In many of them, she recorded the shells' appearances from multiple perspectives.

John George's annotated translation of Lamarck's text was published over three separate issues of *The Quarterly Journal of Science, Literature, and the Arts* in 1823. The journal was intended not for scientists but for general readers interested in the new ideas of the day. An engraver transformed Anna's drawings into etched plates for printing, arranging her pictures of individual shells into composite groups. Each issue of the journal in which John George's text appeared concluded with several plates of these engravings. It was Anna's first published work.

Engraving of Anna Children's drawings by James Basire, 1823

In making these drawings, Anna not only enriched her father's scholarship but also joined a frequently invisible community of women whose abundant contributions have not always received the recognition they deserve. Wives and daughters of male scientists produced many of the illustrations in scientific texts of the eighteenth and nineteenth centuries, and their work helped make complex information clear to readers who may not have had access to actual specimens. Such pictures were not merely adornments to the text but played a vital role in communicating ideas and information. They also taught readers how to make their own observations by showing them what to look for.

Some women's contributions to scientific illustration have remained anonymous to this day. Anna's father was clearly proud of his daughter's achievements, and though the engravings in *The Quarterly Journal of Science* attribute the original drawings only to "A. C.," when the series of articles was printed and bound as a single volume, he gave her credit with her full name in large type on the title page.

Setting the Stage

When Anna stood back and looked at the piles of drawings she had made, she must have felt a tremendous sense of accomplishment. She must have felt even prouder to see these drawings in print. Her illustrations would help make her father's work and Lamarck's theories clearer for hundreds of readers. Anna may not have anticipated what this experience would mean to her twenty years later, as she tackled her own publication on British seaweeds, but the two projects had a few key points in common. By working with her father, she came to grasp how complicated the work of scientific sorting could be. Just as invertebrates did not fit into the Linnaean system for classifying animals, seaweeds did not fit neatly into his system for classifying plants. Like mollusks, seaweeds (or algae, as they were more broadly known) were far less understood than other plants. They also became a new subject of scientific study in Anna's day.

Through illustrating the shells, Anna also saw how important attention to detail was. When it came time to do her own book, she no doubt remembered the labor involved in accurately drawing hundreds of tiny shells. Those memories might very well have made her inclined to try photography as a substitute for

Title page from John George Children's translation of *Lamarck's Genera of Shells,* 1823

The only time Anna's full name appeared in print was on the title page of her father's translation of *Lamarck's Genera of Shells.* Female illustrators did not always receive such public credit, so perhaps her father requested it.

Painting the Way

Anna was not the first daughter to illustrate a father's scientific text or, surprisingly, even the first to illustrate a father's text on seashells. Almost 150 years earlier, the teenage sisters Anna and Susanna Lister earned credit as illustrators on the title page of their father's book. The English naturalist Martin Lister's *Historiae Conchyliorum*, published in four volumes between 1685 and 1692, is considered the original reference in the field of conchology (the study of shells).

Lister believed pictures were critical in conveying scientific ideas. In need of artists who could meet his demanding specifications, he turned to his own talented daughters. He taught them how to look carefully at specimens, sometimes using a microscope, and even to perform dissections. The girls made more than one thousand drawings. And they shared something else with Anna Atkins: while their father's life is thoroughly documented, they are survived only by the beautiful work they contributed to science.

Learning to draw became an essential part of a well-bred young woman's education around the middle of the 1600s. Out of financial necessity, several women did manage to translate their skills in botanical art into a career, using their pencils and brushes to earn an independent living. The Scottish illustrator Elizabeth Blackwell wrote, illustrated, engraved, hand-colored, and published *A Curious Herbal* in 1735 while her husband was in prison. She used the income to pay his debts and free him while supporting herself and her child. The daughter of an artist, Blackwell spent six years studying the medicinal properties of plants and herbs to create a reference book for physicians, the first such "herbal" to be authored by a woman. She drew the five hundred illustrations from specimens she studied while her husband supplied the plants' Latin names from jail. Her book was endorsed by prominent male botanists, and Carl Linnaeus humorously gave her the scientific nickname "Botanica Blackwellia."

Among the women who contributed to scientific study before Anna, Maria Sibylla Merian stands out, both for the quality of her observations and for the beauty of her illustrations. The daughter of an artist and printer, and then stepdaughter of a flower painter in Germany, she began drawing at a young age. Fascinated by insects, she even raised her own caterpillars to study and draw them. She married an artist and published several books of her own work—one of floral engravings, and another on the metamorphosis of butterflies and moths. After leaving (and later divorcing) her husband, she moved to the Netherlands, where she met a circle of scientists. In 1699, amazed by the curious specimens of plants and animals arriving in Amsterdam from the country's colonies, she and her younger daughter traveled to Dutch Surinam (now the country of Suriname) in South America to see for themselves.

Trekking through the dense, humid jungle, Merian made detailed observations and illustrations of the territory's insects and their life cycles. She published several books, including her groundbreaking *Metamorphosis of the Insects of Surinam* in 1705, lavishly illustrated with sixty colored plates based on her drawings, to great acclaim. She assured her legacy not only through her publications but also through her daughters, Dorothea and Johanna, whom she trained in both scientific observation and art.

Metamorphosis of a Small Emperor Moth on a Damson Plum from *The Caterpillar Book* by Maria Sibylla Merian, 1679

this time-consuming work, when it became available. After spending hours bent over her sketch pad to produce a single illustration, she surely would have seen the advantages of a process that allowed nature to "draw its own picture."

John George's book and Anna's future project would have something else in common: the importance of the seaside in nineteenth-century natural history. As improvements in transportation made the seashore increasingly accessible, it became a site where academic and popular science overlapped. Scientists began to consider invertebrates a subject for serious study, and people began to view collecting seashells and fossils on beaches and in tide pools as a healthy, intellectually enlightening, and spiritually uplifting activity. Women, in particular, were encouraged to collect shells. Seashells did not require any special equipment or preparation, and there was no need to deal with the slimy mess of living creatures. Victorians soon filled their parlors with shell collections, decorated them with seashell motifs, and crammed them full of shell-encrusted craft projects. Those who did not wish to exert themselves could purchase shells at beachside resorts or mail-order more exotic specimens from British colonies as far away as India and the Caribbean. Collecting and studying seaweed, as we shall see, provided similar opportunities for women to participate in natural history.

The Conchologist by George Spratt, about 1831

George Spratt made drawings that humorously merged people and objects. His elegant "Conchologist" is composed almost entirely of seashells. A nod to the extreme popularity of shell-collecting, even her elaborate hat is made from a sea urchin.

A Change in Fortune

As Anna completed her work on *Genera of Shells*, another chapter of her life was beginning. Two years after the book's publication, twenty-six-year-old Anna married John Pelly Atkins. The two had been brought together by their connections to Reverend Jordan, Anna's great-uncle, who had cared for her so tenderly while her father and grandfather coped with the fallout from the family's bankruptcy, and who had been John Pelly's mentor. When Reverend Jordan died in 1820, John George and John Pelly (already acquainted through their mutual friend) worked together to help his widow out of a complicated financial situation. During these negotiations, the two men became fast friends. Five years later, on August 30, 1825, John Pelly and Anna were wed in London.

John George was thrilled to see his daughter married to a man he esteemed so highly. Anna described his relationship to his son-in-law and the entire Atkins family as "sincerely and warmly attached" until the end of his life. "Nothing but the hand of death severed those ties," she wrote. After the wedding, the newlyweds moved into a house not far from John George and Eliza so they could visit frequently. We have only a few details of what their life together was like, but Anna and John Pelly were married, apparently very happily, for nearly fifty years.

It was certainly a beneficial match from a financial standpoint, as the Atkinses were wealthy landowners. Anna's father-in-law, John Atkins, was active in politics. He served as London alderman (city council member) from 1808 until his death. He even served a term as Lord Mayor of London from 1818 to 1819. He was also a successful merchant, shipowner, and landholder in the West Indies, a group of islands off the coast of South America where Britain had colonies. His coffee plantations in Jamaica and Bermuda added greatly to his fortune. At that time, the brutal institution of slavery was still in force, and John Atkins was one of many planters who used enslaved people to do the difficult work. Their forced, unpaid labor made the plantations profitable and contributed to the family's wealth.

The extent to which nineteenth-century European "progress" was entwined with and funded by a violent system of colonization and human exploitation is one of the most disturbing truths we must grapple with. As Europeans expanded their control into territories rich in natural resources, they also encountered new plants and animals. Scientists were fascinated by the array of specimens they now had access to, and they shipped samples from the colonies to England for further study, helping them understand botany and zoology in a broader way. Anna's own photography projects would come to include plants gathered in the British colonies of Jamaica, India, and Ceylon (now Sri Lanka), as well as the former colonies in America. But this new scientific knowledge cannot be separated from the devastating consequences of such empire-building for millions of human beings. We have no record of Anna's feelings about either slavery or the origins of her wealth, but her improved economic situation resulted directly in part from this system.

Slavery did, however, end in her lifetime. During the hundreds of years that the Transatlantic Slave Trade was in place, enslaved people found many ways to resist. The largest, most successful of these was the Haitian Revolution, which began in the French colony of Saint-Domingue (now Haiti) in 1791 and ended in 1804 with the first independent Black nation in the Americas. Around the same time in Britain, a movement to abolish slavery was gaining strength. Members of a religious group known as Quakers, who opposed slavery on moral grounds, were organizing abolition campaigns. Even more persuasive were the firsthand accounts of a community of formerly enslaved Black people living in London, which helped to shift public opinion. By the time Anna was a child, members of the British Parliament were debating a law that would abolish the slave trade, which passed in early 1807. However, slavery itself did not end for three more decades. In 1833, when Anna was thirty-four years old, Parliament passed the Slavery Abolition Act, making slavery illegal in Britain and all of its colonies. In order to facilitate this change, the British government paid out millions of pounds to former slaveholders, including Anna's father-in-law, for the loss of their captive labor force. The formerly enslaved men, women, and children received

Cutting the Sugar-Cane by William A. V. Clark, 1823

no such compensation. When Anna and John Pelly later inherited the family plantations in Jamaica, the properties were no longer worked by enslaved people.

The family Anna married into was not only wealthy, it was also socially well respected. Anna's husband, like his father, was a politically active member of his community. Queen Victoria recognized this when she appointed him high sheriff, making him her legal and judicial representative in the county. John Pelly was also a businessman, vigorously campaigning to modernize the region by extending the railroad through Kent. In addition to the income from their overseas properties, the Atkinses had a steady stream of profits from selling timber from their land.

We can imagine that Anna enjoyed a very comfortable life when she moved into their elegant, beautifully furnished home called Halstead Place. The census tells us they had a number of servants working in the household. After enduring bankruptcy and hardship, Anna had reached a financial status higher than the one she had started out with. The couple had no children, so Anna was a woman with the means and the leisure time to pursue her passions. She could now turn her attention to a completely new kind of project.

Sargassum plumosum.

Chapter Two

"Impressions of the Plants Themselves"

A New Home

Anna and John Pelly had begun their married life in London, but they soon settled in at Halstead Place, the Atkins family's home near Sevenoaks in the county of Kent. The grounds were extensive and offered endless opportunities for the study of nature, especially plants. It was here that Anna cultivated her passion for botany. She could wander from the gardens by the house to the fruit orchards and find a variety of specimens to collect and examine. She might explore the fir plantation on the site of a former deer park, or one of several pastures. She could gather flowering campanula and primrose or cut branches from willow and beech trees, without even leaving home.

When Anna was thirty-nine, her father-in-law died, leaving the couple a significant fortune. They inherited his properties in Britain and the West Indies and a number of investments, in addition to Halstead Place. Anna was now its mistress, in charge of overseeing the large home and estate. Her new home was only fourteen miles from Tunbridge, but it was considerably bigger and grander than Ferox Hall. Visitors remarked on its modern architecture and beautifully landscaped grounds, as well as the impressive collection of Old Master paintings John Pelly had assembled while traveling through Europe. A drawing Anna made of Halstead Place around this time shows a gracious building in dappled sunshine, partly obscured by the large mature trees that surround it.

We don't have many details about Anna and her husband's life together, but it is clear from John Pelly's letters that he cared deeply for Anna and had a loving friendship with her father. It was important to her that her father was a welcome member of her new family, and the three of them took pleasure in visiting nearby friends and entertaining at Halstead Place. It seems they also enjoyed traveling together. They spent a month in the English spa town of Bath to "take the waters," as John George's doctor had recommended mineral baths for his ever-fragile health. On the whole, however, information about their day-to-day lives is unfortunately scant.

Sargassum plumosum from *Photographs of British Algae: Cyanotype Impressions* (Vol. I) by Anna Atkins, 1850

St. Margaret's Church and Halstead Place by Anna Atkins, about 1835

Anna sketched the lush grounds at Halstead Place. Her drawing was later turned into this lithograph, which she may have printed herself.

One thing we do know is that science was not just a serious activity but also a form of entertainment for the Atkins family, as it was for many Victorians. One of the ways they amused themselves was with magic lantern shows. A magic lantern, which projected images from glass slides, could be described as the ancestor of the movie projector. The version at Halstead Place was a fancy one that produced "dissolving views." Instead of showing a single image at a time, it had two lenses and used two slides, allowing the first projected image to fade, or dissolve, into a second. Such shows typically featured a scene in two different seasons or times of day, with a sunny day giving way to a sunset, or a summer landscape turning into fall. By the middle of the century, lantern slides often used photographic images, but early ones were painted by hand. Anna's friend Caroline Cornwallis painted many of the slides the family enjoyed.

Anna's father and husband also took great pleasure in tinkering with the apparatus itself. Ever the scientist, John George was determined to apply his knowledge of chemistry to devise a brighter lighting source than candles or oil lamps for the device. After his experiments with hydrogen gas resulted in a small explosion and minor injuries to his face, he deemed the volatile gas impractical for "private houses in the country" and too complicated for household servants to deal with, so he turned to other solutions. He even published a scientific paper on his findings.

The Magic Lantern by Auguste Edouart, about 1835

Imagine the thrill of watching scenes from history, literature, or faraway places appear on a screen in the beam of a magic lantern! Before magic lanterns became widely affordable, traveling showmen called "Galantees" put on private and public shows. In this scene, the seated man plays a barrel organ, accompanying the images with music.

Victorian families collected plants, rocks, and seashells; built terrariums (containers for nurturing plants and small animals indoors); and kept fish as pets. Some even did taxidermy, learning about anatomy while creating natural-history dioramas to display in their homes. They also used a variety of scientific instruments and enjoyed looking at the moon through a telescope, for example. Anna owned a telescope, which her father also used until his interest in astronomy grew serious enough to require a higher-powered instrument. Given the Children-Atkins family's love of science, Halstead Place undoubtedly had a microscope too. Victorians examined the plants and insects they collected, seeing evidence of what they believed to be God's design in the intricate details that magnification revealed. By the middle of the nineteenth century, improvements in lens manufacturing as well as mass production made good-quality microscopes widely affordable. No self-respecting naturalist was without one.

Botany Blooms

Anna was hardly alone in pursuing botany; the whole country was crazy about plants and gardening. This interest had been growing throughout the late eighteenth century, but it exploded in the nineteenth. As Britain industrialized and more people moved from the country to the cities, nature began to take on new importance. Cities were noisy, crowded, and polluted, and they were rapidly growing more so. By 1800, London's population had swelled to one million residents, and by the end of that century it was six times larger. In his 1852 novel *Bleak House*, Charles Dickens described falling soot particles as big as snowflakes and clouds of smoke so black they blotted out the London sun. The countryside tempted urban dwellers with the promise of fresh, healthy air and reminded them of a rural way of life they saw

quickly disappearing. At the same time, the network of railways expanding across Britain made leisure travel possible for a larger swath of the British public. As people explored the lakes or visited country hotels and seaside resorts, plant-collecting became a popular activity.

Victorians could pursue botany just as easily in the home garden as abroad. In *The British Garden* (1799), one of the dozens of botany books published during this time, author Lady Charlotte Murray explained its advantages:

> *The expensive apparatus of the Observatory, and the labours of Chemistry, confine the science of Astronomy, and the study of Minerals to a few; whilst the research into the animal kingdom is attended with many obstacles which prevent its general adoption, . . . but the study of Botany, that science by means of which we discriminate and distinguish one plant from another, is open to almost every curious mind; the Garden and the Field offer a constant source of unwearying amusement, easily obtained, and conducing to health, by affording a continual and engaging motive for air and exercise.*

It was also inexpensive, requiring no special equipment. Open to "every curious mind," the study of nature, whether seashells or plants, was educational, uplifting, entertaining, and healthy.

Botanical gardens provided city dwellers with a new type of green space to enjoy and study nature. On trips to London, Anna surely wouldn't have missed an opportunity to visit the gardens at Kew, which had just opened to the public after a century as a private royal garden. At just a penny, the entry fee was affordable to nearly all Britons. Anna might have started her visit at the Orangery, a large classical-style building for growing citrus fruits. She may have admired the plantings around the Great Pagoda or stopped to see the enormous glass greenhouses, named the Palm House and the Temperate House, being constructed. Or she might have looked in at the new museum and library. Kew also became an important center of scientific research as its botanists collected live and dried plant specimens and seeds from across the globe. Tens of thousands of people came every year to study these exotic plants or simply to marvel at the stench of the Sumatran corpse flowers or the enormous Amazonian water lilies (named *Victoria amazonica* after the queen).

A "Polite" Activity

Anna's love of botany was no doubt fostered by her early exposure to the joys and intrigue of science. It may also have been partly shaped by the gender norms of her day. Although both men and women were interested in botany, women were encouraged to study it—not with the aim of becoming scientists but as part of other "polite" activities such as music, needlework, and drawing. Learning about plants and their classifications was seen as a way for women to cultivate their minds so they might better fulfill what was considered their highest purpose: the education of their children. It also provided an alternative to more "idle" forms of entertainment. Furthermore, collecting and sorting plants had benefits for both the body and the soul. It gave women a chance for some gentle exercise while offering an opportunity to contemplate nature. As women and their work were already strongly associated

with ideas of nature, botany was seen as ideally suited to the nineteenth-century conception of "natural" feminine sensibility.

Anna would have been keenly aware that different rules guided men's and women's participation in science, even in fields like botany. Women could read popular books about plants, sometimes written as a series of letters or conversations and aimed at a female audience (who couldn't read Latin). They could study plants through a magnifying lens or microscope to better appreciate their structures. Using handbooks, they also might collect and identify plants and press them into specimen books called "herbaria." However, even the well-educated daughter of a respected scientist would not be expected (or welcomed) to approach botany the same way a man could. In fact, some men who studied it grew afraid that the field had become too feminized. They began to set more rigid boundaries between their work and that done by women. Before long, the practice of botany followed the same strict gender lines as the rest of Victorian life: men published papers and shared their knowledge through scholarly societies while women were limited to studying plants in the privacy of the home.

Page from an herbarium with a sample collected by Anna Atkins in 1841

This herbarium sheet shows dried, pressed specimens of a type of orchid that grew all over England. Anna collected the one at the upper right near her home. When she donated her herbarium to the British Museum in 1865, her collection was mixed in with other botanists' specimens, such as the one on the bottom found by a Mr. Gardiner in Fife, Scotland.

Anna channeled her own curiosity into assembling a large herbarium (a collection of pressed plants). She carefully selected examples from the grounds at Halstead Place, as well as on her travels in Derbyshire and Surrey Counties (among other places). Pulling them up, roots and all, or snipping branches from the trees, she pressed each sample between thick sheets of blotting paper until it was flat and dry. Then, using glue and a tiny strip of paper to hold the stem in place, she attached the specimen to a different sheet of paper, labeling it by hand with its Latin name and the place where she had found it. Her collection soon grew large enough that her father found it worth mentioning in a letter to Britain's most famous botanist, William Hooker. John George wrote, "My daughter, Mrs. Atkins, has a great fondness for Botany, and is making an Herbarium; tho at present she confines herself to British plants." Anna continued to add to her herbarium for her entire adult life.

Networks of Knowledge

Anna's herbarium served an important purpose beyond just personal enrichment. Though women were not expected or permitted to contribute to scientific knowledge in the same ways men were, they made quietly essential contributions without which the work of male botanists like Hooker could not proceed. Specimen collections formed the basis of almost all botanical research, and a great many of these were assembled and donated by women.

Hooker depended on the work of dozens of female plant collectors around the globe who sent him specimens for study. (So, for that matter, did Charles Darwin, who had numerous female correspondents and researchers.) British women contributed their comprehensive collections of native plants, while wives of colonists in Australia, India, and the Caribbean sent him valuable samples of exotic flora from across the empire. Hooker sometimes provided them with lists of requests, and even supplied reference books and microscopes to assist them. His research activities resemble a kind of nineteenth-century crowdsourcing: these women, whose work is rarely recognized, provided field coverage that would have been nearly impossible to secure otherwise.

Botany also built social networks among women. They collected specimens together and exchanged them to fill gaps in their collections. Anna and Anne often hunted for plants side by side, sometimes in the company of Anna's father. Some of their joint outings are preserved on the sheets of Anna's herbarium, which includes samples gathered by all three of them, marked with each of their names. Anne seems to have been as serious as Anna about plant-collecting. On at least one occasion, John George wrote straight to Hooker himself on Anne's behalf to ask for help identifying a particular species. Around 1839, Anna further expanded her community by joining the new Botanical Society of London, one of the only scientific societies to admit female members. She was likely encouraged by her father, who had joined the year before and was elected vice president. The decision to establish a scientific organization with the intention of allowing women to join was almost unheard of. One man, describing the plan, used three exclamation points to emphasize his disbelief: "It has been proposed that *Ladies* should be admitted!!!"

Although they were welcome, women still made up only a small minority (about 10 percent) of the Botanical Society's membership. The women who did join seem to have shared certain characteristics: like Anna, nearly every female member had a close male relative who was interested in science, and at the time of the group's founding, none of the women had children. They therefore had more time to devote to their own interests. Women members attended the twice-monthly meetings where they kept abreast of the latest research, but they were not expected to generate such research or present papers. They were, however, active participants in one of the society's other chief activities: the exchange of specimens. The society had a museum, a library, and an herbarium to which members contributed, and they also traded specimens with one another.

Anna's education, combined with her experience in collecting, preserving, and sharing specimens, gave her a solid foundation from which to tackle a major project in botanical illustration. She would also come to rely on her network of plant-loving friends to round out her own collection as she assembled the seaweed specimens for *Photographs of British Algae*. Many of them were likely fellow members of the Botanical Society.

The same year Anna joined the Botanical Society, her stepmother, Eliza, died. Eliza had been unwell for nearly two years, and had often been confined to home, finding comfort in the singing of her pet canaries and spending time with John George in the countryside. Despite her illness, the family celebrated the wedding of Anna's beloved friend Anne to the Reverend Henry Dixon, the vicar of Ferring in Sussex, in the spring of 1837. Anne's new husband was already a friend of Anna's father and husband, and John George was thrilled by the match. Yet, even with these small moments of joy, it was a difficult period. Though Anna was an adult when Eliza joined the Children family, Eliza had been the closest thing she had to a mother in her life. She was especially grateful to her stepmother for the care she had shown her father as his "faithful partner of the last twenty years." After her death, John George decided to retire from his job at the British Museum. Though he loved the work, he was tired. He sold some of his collections, left his apartment at the museum, and moved to Halstead Place, where once again father and daughter were united under the same roof.

Of Mousetraps and Fairy Pictures

John George and Anna may have found a distraction from their sadness in the news of a rather miraculous discovery that reached Britain in early 1839. The English scientific societies were abuzz with the announcement that the French diorama painter Louis-Jacques-Mandé Daguerre had invented a process for permanently recording the images made in something called a camera obscura.

The camera obscura, whose Latin name literally means "dark chamber," had been around for centuries. First described in China as early as 400 BCE, it had long been used by artists (including Leonardo da Vinci) to accurately transfer images onto paper or canvas. It was a simple device made from a totally darkened box or room with a small aperture through which a narrow beam of light could pass.

Illustration of a camera obscura from *An Elementary Treatise on Physics* by Adolphe Ganot, 1882

Camera obscuras came in different forms, but they all coupled a dark enclosure with a small opening that allowed light to enter. The portable version shown here is equipped with a mirror to throw the projected image upward onto a sheet of frosted glass. The artist has laid his paper on top and is simply tracing what he sees on the glass.

William Henry Fox Talbot by John Moffat, 1864

When William Henry Fox Talbot had this portrait made, twenty-five years after inventing photography, he brought his camera with him. People sometimes posed with props that represented their social status or profession. Talbot removed the camera's lens, demonstrating the technology of photography and his mastery of it.

This opening could be as simple as a pinhole or as complex as a glass lens. The light shining through the aperture projected the image of the world outside the camera obscura onto its interior wall. The image was upside down and reversed left to right, but this could be easily corrected with a mirror. These devices were also entertaining; people could gather inside room-size camera obscuras to watch images of the world outside. During the Victorian era, they were especially popular attractions at the seaside. Though easily explained through the laws of optics, the experience of standing in the dark and watching moving, lifelike images of the sun on the waves and the crowds on the beach seemed almost magical.

But unless an artist then drew them, the images formed inside the camera obscura were not permanent. They offered only a fleeting view of the world in real time. The idea that Daguerre had somehow managed to freeze these temporary pictures without a pencil—and trap them permanently—captured the imagination of scientists and the public alike.

The members of the Royal Society were especially intrigued by the news of Daguerre's invention. One member in particular was more alarmed than captivated by these reports. William Henry Fox Talbot, a gentleman with scholarly interests that ranged from mathematics to Egyptology, had himself experimented with recording the images in a camera obscura several years earlier. Frustrated by his limited artistic skill while making sketches on vacation, Talbot had begun to wonder if it might be possible to record images without having to draw them at all:

> *This led me to reflect on the inimitable beauty of the pictures of nature's painting which the glass lens of the Camera throws upon the paper in its focus—fairy pictures, creations of a moment, and destined as rapidly to fade away. . . . how charming it would be if it were possible to cause these natural images to imprint themselves durably, and remain fixed upon the paper.*

From his extensive knowledge of chemistry, he knew that certain silver compounds turned dark when they were exposed to sunlight. He completed a series of experiments to make this reaction move more quickly, and then to stop it and keep the silver from continuing to darken.

Talbot used the results of these experiments to make pictures. At first, he made prints by placing objects (like pressed plants or pieces of lace) on top of writing paper that was painted with a solution of ordinary table salt and silver nitrate, and then exposing them to light. Everywhere the sun hit the paper, the silver turned dark, leaving a precise white shape where the object had blocked the sun's rays. Today we call this kind of photographic picture, made without a camera or lens, a photogram. With somewhat less success, Talbot also began placing sheets of light-sensitive paper inside small, hand-built cameras, which his wife, Constance, teasingly nicknamed "mousetraps." He called his new kind of pictures "photogenic drawings": drawings made by light.

However, by the end of 1835, Talbot had set his experiments completely aside, his attention occupied by other projects. News of Daguerre's invention in early 1839 made him immediately concerned that his own discoveries had been scooped. His mother, Lady Elisabeth Feilding, was even more upset. She wrote him a letter criticizing him harshly for his delay in publishing his research. (It seems that not even an inventor of photography was safe from a scolding from his parents!) She went on to say, "[T]his is *at least* the second time the same sort of thing has happened, how I do wish it might operate in future as a spur to make you do yourself justice."

Because Daguerre was trying to convince the French government to give him money for his process, he kept the details of how it worked completely secret. Only a handful of people had even seen the pictures it produced. With little information to go on, Talbot had to assume that Daguerre's experiments and results mimicked his own. He rushed to present and publish his findings at the Royal Society the following month to prove that his work had come first.

Photography Gets Its Name

We could say that John George was present at the birth of photography in Britain, and as a result, so was Anna. It is easy to imagine that he shared the exciting developments being discussed at the Royal Society with his daughter. And one or both of them may very well have gone to the Royal Institution on January 25, 1839, when Michael Faraday spoke about Talbot's discovery to an audience of some three hundred people and displayed samples of his photogenic drawings. John George could not have been closer to the action. He attended the January 31 meeting of the Royal Society, when Talbot read "Some Account of the Art of Photogenic Drawing, or the Process by which Natural Objects May Be Made to Delineate Themselves without the Aid of the Artist's Pencil," in which he described his discoveries at length. And as vice president and former secretary of the Royal Society, John George presided over the February 21 session, at which Talbot publicly revealed his method with enough detail that his experiments could be replicated.

Talbot's discoveries inspired scientists all across Europe to try their hand at photogenic drawing. The experiments of his close friend and colleague Sir John Herschel were ultimately the most consequential for his work. Not only did Herschel improve Talbot's method for halting the development of the chemistry, or "fixing" his photogenic drawings to make them more permanent; he also gave the entire process a name. In March of 1839, Herschel presented his own findings on light-sensitive materials to the Royal Society in a paper titled "Note on the Art of Photography," and the name stuck.

Calotypes: "Beautiful Pictures"

Anna's father was immediately enthusiastic about photography, and he was keen to learn more. He went directly to the inventor for more details and samples of the new art that he and Anna could study firsthand. As fellow members of the Royal Society, John George and Talbot knew each other and had corresponded for nearly a decade about their research projects. Now John George could take advantage of this friendship to learn more about Talbot's ongoing experiments. He was interested in the improvements Talbot had made to the light-sensitivity of his chemistry that finally allowed him to make pictures in the camera obscura itself. The pictures made in the camera, called negatives, were tonally reversed, meaning that light objects showed up dark, and dark objects were light. From these negatives, a second print (with the tones reversed again to appear correctly), called a positive, could be made. One negative could produce unlimited identical prints.

Talbot's negative-positive process formed the basis for modern photography for over 150 years. It was not until the invention of digital cameras that the chemical process was bypassed entirely. Talbot called his pictures "calotypes," from the Greek for "beautiful pictures." (Once again, his mother had an opinion: she thought her son should follow Daguerre's lead and call them "Talbotypes.")

Anna's father wrote to Talbot to request a copy of his paper, which Talbot sent him, along with twelve calotype photographs. Talbot also recommended that John George seek out Henry Collen to learn more about the process. Collen was a painter of miniature portraits, as were a great many early photographers who, rather than watch photography put them out of business, chose to learn to use the new technology. He was also the first person to purchase a license from Talbot to practice his calotype method. In September of 1841, John George wrote to Talbot to thank him and to express his excitement about pursuing photography with Anna:

> *Your kind Letter followed me to the Isle of Wight, and on my return to Town I found the Calotypes safe on my table. . . . The Specimens you have so liberally sent me, are beautiful, and when we return to Kent, my daughter and I shall set to work in good earnest 'till we completely succeed in practicing your invaluable process. I am also extremely obliged to you for introducing me to Mr. Collen—from whom I have received much valuable information. I have sat to him for my Calotype this morning. I have also ordered a camera for Mrs. Atkins from Ross.*

John George was so eager that he bought Anna a photographic camera so the two could get right to work. He sought Collen's technical advice, as Talbot suggested, but he was also curious to see the process in action, so he had his own portrait made. Though making photographic portraits would soon become common, in these early days it was difficult, and therefore unusual. Depending on the lighting conditions, exposures could take several minutes, during which a sitter had to hold perfectly still or else show up as a blur. Early portrait photographers relied on special clamps to hold their sitters' heads motionless during the exposure.

How exciting it must have been when Anna's camera arrived at Halstead Place from the London optician Andrew Ross! Early photographic cameras were essentially small camera obscuras, specially designed to hold light-sensitive paper. Anna's would

have looked like a simple wooden box with a brass lens that sat on a tripod. Such cameras were too cumbersome to hold, and impossible to keep still without a support. It was a good-quality instrument, too. Ross was famous for his lenses for telescopes and microscopes, but like many opticians, he immediately turned his skills to manufacturing lenses for photography. John George had promised Talbot that he and Anna would work until they had mastered his calotype process.

What did they photograph? Unfortunately, we will never know. None of the photographs they must have made with the camera have ever been found. They probably made pictures of still lifes—arrangements of fruit, flowers, or household objects that they set up to practice composition and exposure. They likely tried to capture views of the lush grounds or stately buildings at Halstead Place, subjects that would naturally hold still for a photograph. A poem John George wrote suggests that they even dared to try portraiture but had no success. Sadly, even if these photographs had been found, most likely their images would have long since faded away. Despite continual improvements, making images permanent was the single greatest challenge early photographers faced.

Cyanotypes: "Blue Impressions"

Despite John George and Anna's keen interest in learning to make calotypes, they soon turned their attention to making a different kind of photograph: cyanotypes. This process was another of Herschel's discoveries. Like Talbot, Herschel was a colleague of Anna's father, but he and his family also lived nearby and socialized with the Children-Atkins household. While we don't know a great deal about their friendship, the two families were obviously close: at her death, Anna bequeathed a complete copy of *Photographs of British Algae* to Maggie Herschel, the scientist's wife.

Herschel immediately became engrossed in photographic chemistry after Talbot's process was made public. He tested silver, along with platinum, gold, mercury, and lead, as well as the colored juices of plants to see how they reacted to light. (His experiments were so thorough that he even tried dog's urine and an unspecified "extract" from his pet boa constrictor.) In 1842, he found that certain iron salts not only were light-sensitive but also produced vivid blue-and-white prints. Following the model Talbot set with "calotype," Herschel called his prints "cyanotypes," meaning "blue impressions." We know from Herschel's records that he sent a copy of his research directly to Anna's father. He may very well have taught them how to make the prints himself.

Cyanotype made from an engraving, by John Herschel, about 1842

While developing the cyanotype, Herschel sometimes used engravings to make his pictures. He placed these engravings directly on top of a piece of paper coated with chemicals and exposed them to sunlight. Although Herschel's primary interest was light, many people saw photography's potential as a new way for copying manuscripts and artworks.

Sir John Herschel by Julia Margaret Cameron, 1867

John Herschel
Inventor of the Cyanotype

Sir John F. W. Herschel (1792–1871) was considered the leading British scientist of his day. Born at an observatory into a family of astronomers—his father, Sir William, discovered the planet Uranus, and his aunt Caroline was also a noted astronomer—John was destined to follow suit. His contributions extended far beyond his groundbreaking observations of the stars, however. He was admitted to the Royal Society on the basis of his work in mathematics, and he was acclaimed for his accomplishments in chemistry. He was also involved in research on electricity, magnetism, acoustics, and geology. Today scientists usually focus on a single, often very narrow field, but in Herschel's day the idea of a professional, specialized scientist was just beginning to emerge. The same man could write knowledgeably on a surprisingly wide variety of topics. Herschel's studies of nebulae (giant clouds of gas and dust in space), double stars, and the sun expanded into research to better understand the physical properties and chemical actions of light itself.

When William Henry Fox Talbot announced his invention of photography in 1839, Herschel had already been experimenting with a similar process. Within a week, he had solved one of Talbot's major challenges: early photographic images faded very quickly. Drawing on his 1819 discovery that hyposulfite of soda is the only chemical that can dissolve silver salts, Herschel invented a formula to make the images permanent, or "fix" them. (Photographers still call this fixer solution "hypo.")

In addition to popularizing the term "photography," Herschel drew on his research in electricity to coin the terms "negative" and "positive" to describe the tonally reversed image made in the camera and the photographic print that was made from it. Overall, however, he was far less interested in photography as an art form than he was in its potential to explore the properties of light. As he wrote to his wife in 1841, "Light was my first love."

Anna used Herschel's cyanotype process to execute the thousands of prints that made up *Photographs of British Algae*. She was not, however, the only important female photographer to learn about the medium from the scientist himself. Julia Margaret Cameron, considered one of the nineteenth century's greatest photographic artists, met Herschel in 1836 in South Africa, where he was on an astronomical expedition. They struck up a correspondence and friendship that lasted three decades, and it was Herschel who sent her (then living in India) the news and details of Talbot's discovery. Cameron, whose male subjects composed the scientific and literary luminaries of British society, referred to Herschel as "a Teacher and High Priest." She made this photograph of him in 1867.

Even without his instruction, Herschel's cyanotype process would have been quite simple for John George and Anna to replicate. It required only a basic familiarity with chemistry (which John George certainly had) and access to lots of clean water (which Halstead Place had). It depended on two widely available and relatively inexpensive chemicals: ferric ammonium citrate and potassium ferricyanide. Their interaction produced the synthetic pigment known as Prussian blue. After mixing the solution, Anna had only to brush or sponge it onto ordinary writing paper and leave it to dry in the dark. Once dry, the coated paper was ready for Anna to use. She placed her specimen on top of the paper, exposed it to sunlight for a few minutes, and then washed it in clean water to develop the pigment and rinse away the unexposed chemicals.

In addition to being easier than Talbot's multi-step process, Herschel's turned out to be far more stable, making images that resisted fading. Although John George was the experienced chemist, it was ultimately Anna who envisioned and exploited the possibilities of Herschel's cyanotypes.

Creating *Photographs of British Algae*

Although her attempts at making calotypes may not have survived, Anna's extraordinary efforts with the cyanotype have earned her a place in the history of photography. Almost immediately after learning about Herschel's method, she decided to put it to work. Not content to simply experiment, Anna set out to create an entire book—an illustrated guide to the seaweed of Britain. Early on in her project, she described her work to a close friend, Sophia Bliss:

> *I have lately taken in hand a rather lengthy performance, encouraged by my father's opinion that it will be useful—it is the taking Photographical impressions of all (that I can procure) of the British Algae and confervae [a specific type of algae], many of which are so minute that accurate drawings of them are very difficult to make.*

Anna used the cyanotype process to create every part of her book, from the elegant plates to the bright blue paper she wrapped them in. On each of the plates, she depicted a single specimen of seaweed labeled with its Latin name. She began by placing the specimen on her prepared paper. To make the labels, Anna wrote the Latin names in opaque ink on scraps of paper that she had oiled to make them translucent. She placed the labels next to the specimens, laid a sheet of glass on top, and put the whole thing in the sunlight. Both the plant and the ink blocked the light from exposing the chemicals, resulting in a picture that showed the seaweed's form and its scientific name in white against a blue background.

In October of 1843, Anna completed and sent out the first part of what would become the three-volume book *Photographs of British Algae: Cyanotype Impressions*. Each copy of this first slim booklet contained a title page, an introduction, and a table of contents. Each also included a special detail—an affectionate dedication to her father, written in her own hand and copied by the same photographic process. She produced all of these features the same way as the labels, by writing the text in opaque ink on oiled paper and then using that paper to make a cyanotype print. She sewed these pages together by hand, along with eight beautiful plates depicting seaweed, and wrapped it all in blue paper, also produced by cyanotype.

Title page from *Photographs of British Algae: Cyanotype Impressions* (Vol. I) by Anna Atkins, 1843

> The difficulty of making accurate drawings of objects as minute as many of the Algae and Confervae, has induced me to avail myself of Sir John Herschel's beautiful process of Cyanotype, to obtain impressions of the plants themselves, which I have much pleasure in offering to my botanical friends.
>
> I hope that in <u>general</u> the impressions will be found sharp and well defined, but in some instances (such as the Fuci) the thickness of the specimens renders it impossible to press the glass used in taking Photographs sufficiently close to them to ensure a perfect representation of every part. Being however unwilling to omit any species to which I had access, I have preferred giving such impressions as I <u>could</u> obtain of these thicker objects, to their entire omission — I take this opportunity of returning my thanks to the friends who have allowed me to use their collections of Algae on this occasion.—
>
> The names refer to Harvey's "Manual of British Algae". I have taken the Tribes and Species in their proper order when I was able to do so, but in many cases I have been compelled to make long gaps, from the want of the plants that should have been next inserted, and in this first number I have intentionally departed from the systematic arrangement, that I might give specimens of very various characters as a sample.
>
> A. A.

Introduction from *Photographs of British Algae: Cyanotype Impressions* (Vol. I) by Anna Atkins, 1843

Anna could have had this introduction set in type and printed on a press. Instead, she chose to reproduce her own handwriting. We might see her decision as giving the book an intimate, personal feel; more likely, she was thinking broadly about photography's unique ability to produce a stand-in for the thing itself—in this case, her own penmanship.

"Impressions of the Plants Themselves"

Dedication from *Photographs of British Algae: Cyanotype Impressions* **(Vol. I) by Anna Atkins, 1843**

Laminaria saccharina from
*Photographs of British Algae:
Cyanotype Impressions* (Vol. I)
by Anna Atkins, 1843

Delesseria sanguinea from
Photographs of British Algae: Cyanotype Impressions (Vol. I)
by Anna Atkins, 1844

Rhodomela subfusca from
*Photographs of British Algae:
Cyanotype Impressions* (Vol. I)
by Anna Atkins, 1846–47

Asperococcus pusillus.

Gigartina purpurascens.

Laurencia pinnatifida.

Halymenia furcellata.

56　**Chapter Two**

It is hard to imagine the labor that went into a project of this size. Before she could even make the photographs, she had to gather the specimens, identify them, and assign their proper Latin names, an immense undertaking in itself. To make the photographs, she needed an actual piece of each kind of seaweed. It took considerable time for her to collect the samples—even with the help of friends who lent her their own specimen collections—and as a result, she wasn't always able to stick to her intended sequence. Her plan had been to follow the order of William Harvey's recently published book on seaweed, *A Manual of the British Algae* (1841), but in her introduction Anna acknowledged this had not always been possible:

> *The names refer to Harvey's* Manual of British Algae. *I have taken the Tribes and Species in their proper order when I was able to do so, but in many cases I have been compelled to make long gaps, from the want of the plants that should have been next inserted.*

She also had to adjust her setup to accommodate seaweeds of different size and thickness. Not all of them were ideally suited to the cyanotype process. Some were so thick that she couldn't flatten them between the glass and the sensitized paper, which made some areas of the image less sharp. Nonetheless, she felt it was important to include any seaweed she could obtain a sample of, even if she could not produce an ideal image:

> *Being however unwilling to omit any species to which I had access, I have preferred giving such impressions as I could obtain of these thicker objects, to their entire omission—I take this opportunity of returning my thanks to the friends who have allowed me to use their collections of Algae on this occasion.*

As far as we know, Anna made all of the cyanotypes herself. Her friend and fellow plant-lover Anne Austen may have helped, and she certainly depended on the household servants at Halstead Place, who probably had to pump and haul the large quantities of clean water that were needed to wash the prints.

Anna produced thousands of plates over the following decade, hand-painting each with chemicals, and then drying, exposing, washing, and drying them again. She didn't just make one photograph of each specimen; she had to make numerous prints to make multiple books. Though we might be tempted to refer to these multiple prints as copies, they were not copies at all. Anna used the same specimen to make each plate, but she had to reposition it by hand on the sensitized paper for every single print, leading to slight variations among them.

By May of 1844, she had completed two more parts, each with twelve plates and a table of contents. She hand-sewed the prints into booklets to distribute to her list of recipients. It took her another six years to produce and send out twelve more parts and complete Volume I.

The way Anna produced and distributed her book, in booklets or parts (often called fascicles), was a common form of publication in the 1800s. Part-books let the author or publisher work in stages and spread out the costs of production over time. Many novels were

Top left: *Asperococcus pusillus* from *Photographs of British Algae: Cyanotype Impressions* (Vol. I) by Anna Atkins, 1849

Top right: *Gigartina purpurascens* from *Photographs of British Algae: Cyanotype Impressions* (Vol. I) by Anna Atkins, 1846–47

Bottom left: *Laurencia pinnatifida* from *Photographs of British Algae: Cyanotype Impressions* (Vol. I) by Anna Atkins, 1846–47

Bottom right: *Halymenia furcellata* from *Photographs of British Algae: Cyanotype Impressions* (Vol. I) by Anna Atkins, 1850

also sold this way, and nineteenth-century readers waited excitedly to read the next episodes. (Charles Dickens's novel *The Pickwick Papers*, for example, was published serially in nineteen parts between 1836 and 1837.) Though Anna gave her books as gifts, in commercial publishing this approach also allowed people who could not afford to pay for a book all at once to purchase it in installments.

Anna's decision to issue her book in parts was no doubt due to the time-consuming work of producing hundreds of cyanotypes. Working in pieces, she sometimes found that despite her best planning, she had made mistakes along the way and had to make corrections. In late 1850, she sent out one final part of Volume I that included extra plates, as well as instructions for removing certain previously mailed plates and replacing them with the new ones. She also enclosed a new table of contents for the entire book that would replace the partial ones included in the smaller installments. As with all part-books, it was the recipient's job to have the pieces professionally bound into a volume. Not everyone interpreted her detailed instructions for removing and replacing plates in the same way. As a result, each copy of Anna's book that survives today is one of a kind.

A Surge of Sea-Weeding

Anna's choice of subject—seaweed—was as modern as her decision to use photography. Like the interest in botany in general, the British obsession with seaweed and seaweed-collecting began at the end of the 1700s with aristocrats who visited the seashore. (Queen Charlotte, the wife of "mad" King George III, who was known for her love of both botany and fashion, wore dresses made of seaweed-patterned fabric.) But by the mid-1800s, the middle class had also caught the seaweed craze. Tourists flocked to the seashore by train, armed with guidebooks to help them identify the plants they found. The clean salt air was thought to be especially healthful, and doctors recommended its restorative properties to women recovering from illness or pregnancy. Anna's own mother had been sent to the seaside when she fell

COMMON OBJECTS AT THE SEA-SIDE—GENERALLY FOUND UPON THE ROCKS AT LOW WATER.

***Common Objects at the Sea-Side—Generally Found upon the Rocks at Low Water* by John Leech, 1858**

Victorians loved witty cartoons, such as this one poking fun at the sea-weeding craze. The artist compares the swarm of bent-over and apparently headless collectors with the "common objects at the sea-side" they are hunting.

Gathering Seaweed by Frederick Richard Lee, about 1836

ill after giving birth. As with all study of nature, "sea-weeding," as it was popularly called, also offered an opportunity for moral uplift and self-improvement.

Gender norms not only steered women toward acceptable fields like botany but even influenced the kinds of plants they studied. Like the seashells Anna had drawn for her father's book, seaweed was both a new subject of serious scientific research and a popular topic for amateurs to explore. Ironically, the same reason previous generations of male botanists had ignored seaweed now made it an appropriate subject for the "gentler sex": it reproduced asexually. The widely used

A Sisterhood of Sea-Weeders

Seaweed-collecting became a full-blown mania among Victorian women. It was a wet and slippery business, and traditional female clothing was not well suited for it. Sea-weeding guides advised collectors on how to dress for the activity, as long skirts and delicate leather shoes were hardly ideal for tromping around tide pools. There was also concern that the bending and reaching required to gather specimens might cause women to adopt postures that were unintentionally revealing. Margaret Gatty, whose book *British Sea-Weeds* (1863) was one of the most popular, advised women they "must lay aside for a time all thought of conventional appearances, and be content to support the weight of a pair of boy's sporting boots." However, she explicitly counseled against going so far as to wear men's trousers, recommending woolen layers and sensible ankle-length petticoats instead.

Despite the gendered dress code, women found the seaside a liberating environment, several degrees looser than at home. As Gatty vividly described to her "sisterhood" of seaweed enthusiasts:

> *to walk where you are walking makes you feel free, bold, joyous, monarch of all you survey, untrammelled, at ease, at home! At home, though among all manner of strange, unknown creatures, flung at your feet every time by the quick succeeding waves.*

Pressed seaweed specimens gathered by women in Jersey, England, 1850s and 1860s

Women collected and pressed seaweed to put in albums like this one. This particularly beautiful example also shows off and preserves the bright colors, something photography could not yet do.

Linnaean system sorted plants based on the number of male and female reproductive organs they had (known as stamens and pistils), but seaweed, mosses, and ferns reproduced by spores rather than seeds. They did not fit neatly into his system because they had no visible reproductive organs. Even though plants had been sorted in this way for over a hundred years, some Victorians began to worry that the emphasis on reproduction might not be appropriate for female learners. Since seaweed avoided this concern altogether, it was deemed a safe and wholesome subject for women.

The long coastline of England and its many tide pools offered endless opportunities for collecting, and Anna's home was only twenty miles from the sea. We know she traveled to the Isle of Wight, which offered excellent opportunities for sea-weeding, as well as other sites in Britain. Like many women, she would have put on sturdy shoes and picked her way over slippery rocks to collect her specimens. She kept them damp in an oilskin pouch or a glass bottle until she could rinse them in fresh water and then float the plants into place on a piece of paper. She then pressed the specimens between paper and a piece of cloth until they dried. Anna had used thin paper strips and glue

Algae Danmonienses, or Dried Specimens of Marine Plants, Principally Collected in Devonshire by Mary Wyatt, 1835

Mary Wyatt's guide was illustrated entirely with actual specimens like the one seen here. Wyatt was a former servant in the home of Amelia Griffiths (the so-called Queen of Algologists), who taught Wyatt to collect and identify the plants.

to hold down other kinds of plants, but seaweed made its own naturally sticky compounds that worked as an adhesive. She very likely learned the technique from one of the many instructional handbooks for women on collecting and preserving seaweed, such as Elizabeth Anne Allom's *The Sea-Weed Collector* (1841). As the craze spread, more guidebooks were published, including Isabella Gifford's *Marine Botanist* (1848) and Anne Pratt's *Chapters on the Common Things of the Sea-Side* (1850).

Some women used seaweed-collecting as an opportunity to study, classify, and name the species they found and press them into herbaria, as they did for other kinds of plants. These collections ranged from personal albums for private enjoyment to Mary Wyatt's multivolume *Algae Danmonienses, or Dried Specimens of Marine Plants, Principally Collected in Devonshire* (1835), which she produced in multiple copies for sale at her seashell shop in Torquay. A very few female sea-weeders became experts in their own right, like Amelia Griffiths, who discovered and described several previously unknown species. Griffiths corresponded with many male algologists, including William Harvey. Although she was known as the Queen of Algologists, and her herbaria are now in important scientific institutions, she never published any of her own discoveries. But it was Griffiths who suggested to Harvey that he publish his reference guide, and his *A Manual of the British Algae* became the definitive guide to British seaweed for decades.

Anna's Innovation

Harvey's text, however, had no pictures. To use it as a field guide, readers would have had to try to match the plants they found to the author's descriptions. Imagine trying to learn biology without an illustrated textbook! Harvey recommended that his readers supplement his text by purchasing the collections of dried specimens Mary Wyatt had assembled in her book, but Anna had sensed an opportunity: could the new invention of photography provide an alternative form of illustration?

Albums packed full of dried specimens were not especially convenient. Because they were made using actual plants, they were limited in quantity, and they were

Specimens of Sea Weed by unknown maker, about 1840

The title page of this album features a paper basket overflowing with vivid seaweed "flowers." Underneath, the book's unknown maker has written lines from a poem: "Call us not weeds, we are flowers of the sea / For lovely and bright and gay-tinted are we."

Title page from *Sea Weeds 1848* by Eliza A. Jordan

Most women's seaweed albums resembled scrapbooks more than scientific texts. Though Anna had a different goal for her own book on seaweed, she clearly borrowed from their style to form the titles for her volumes.

62 Chapter Two

bulky and fragile. Drawing was in some ways more practical than actual specimens, but as Anna knew from illustrating *Lamarck's Genera of Shells*, it had the potential to be less accurate. Photography seemed to offer a new solution. The pictures it produced were accurate, efficient, and reproducible.

Atkins clearly intended her multivolume seaweed photographs to serve as a serious reference guide, much like Wyatt's encyclopedic collection and Harvey's manual. It is easy to overlook, however, the small ways she was influenced by other kinds of books on the subject. Many sea-weeders used the vibrantly colored and fantastically shaped plants to create elaborate albums and scrapbooks. They decorated them with drawings, watercolors, pressed flowers, and scraps of lace or other materials. Even Queen Victoria caught the bug and made a seaweed album. Sea-weeding guides encouraged women to use "ocean flowers" much the same way they did blooms from their gardens. They taught women how to arrange the plants into pictures or use the delicate fronds to form letters or text. Anna clearly borrowed a little of this aesthetic. Using tiny pieces of seaweed (or possibly drawings similar to them), she formed wispy letters that look like they emerged organically from the sea to create fanciful title pages for each volume of *Photographs of British Algae*.

Title page from *Photographs of British Algae: Cyanotype Impressions* (Vol. III) by Anna Atkins, 1853

Photography's Pros and Cons

Though Anna's book broke new ground, she was not the first to think of using photography as a new form of botanical illustration. This was one of the first ways photographers, including Talbot, thought to use the new image-making process. Talbot was a keen botanist, and he used plant specimens as the earliest subjects of his photogenic drawings:

> *The first kind of objects which I attempted to copy by this process were flowers and leaves, either fresh or selected from my herbarium. These it renders with the utmost truth and fidelity, exhibiting even the venation [vein system] of the leaves and the minute hairs that clothe the plant, &c.*

So, too, did many others who rushed to try Talbot's process. Golding Bird, a medical doctor, published some of his own efforts just two months after Talbot made his formulas public. In a letter to the editor of *The Magazine of Natural History*, Bird explained the advantages of photography to the study of botany: "I feel that the application of this heliographic or photogenic art will be of immense service to the botanist, by enabling him to procure beautiful outline drawings of many plants, with a degree of accuracy which, otherwise, he could not hope to obtain." Members of the London Botanical Society also experimented with botanical photography, and Anna may have seen a demonstration of photograms of mosses displayed at a society meeting in March of 1839.

"Fac-simile of a Photogenic Drawing" by Golding Bird, from *The Mirror of Literature, Amusement, and Instruction*, 1839

News of Talbot's invention spread quickly through popular journals. There was no way yet to print actual photographs in magazines or books; the journals could only publish "facsimiles" (engraved reproductions). Many of the early examples, like this one, featured botanical subjects.

Talbot insisted that photographs were also far better than written descriptions, which he thought were vague at best and totally inaccurate at worst. If travelers could have sent home photographs of the specimens they found, he wrote, it would have "greatly aided modern botanists in determining the plants intended by those authors, whose descriptions are frequently so incorrect that they are like so many enigmas, and have proved a hindrance and not an advantage to science." Like Talbot and Bird, Atkins understood photography as providing an essential supplement to written texts and an accurate and elegant substitute for difficult and time-consuming drawing. She was explicit about this second benefit in her introduction to *Photographs of British Algae*: "The difficulty of making accurate drawings of objects as minute as many of the Algae and Conferva, has induced me to avail myself of Sir John Herschel's beautiful process of Cyanotype, to obtain impressions of the plants themselves, which I have much pleasure in offering to my botanical friends." The delicate structure of some of the more miniature seaweeds in Harvey's book would have been daunting to any artist. Anna's photograms reproduced them at life-size while still recording the tiniest details.

Though many people saw photography as more accurate than drawings, photographs did have some rather significant shortcomings as a form of botanical illustration. Traditional drawn or painted illustrations depicted an idealized or perfect specimen of a plant, often as it would look in multiple seasons or stages of development, but all in one picture. Photograms like Anna's, on the other hand, showed a single, dead, flattened, specific plant at one moment in time. How could people match these pictures to living plants in another season? How would they know if the individual plant

Talauma Hodgsoni from *Illustrations of Himalayan Plants* by Joseph Hooker, 1855

While a photograph could only depict a single, colorless specimen, this vibrant illustration shows the plant's characteristics over several stages of growth. We can see the Himalayan magnolia's seed pod, bud, and flower all at once. We can even see the pod dissected and magnified.

was typical of the species it was supposed to represent? Photograms also couldn't show the interior details; only the distinctive outlines were preserved. Anna's project in particular had another challenge: Harvey's classifications of algae were based on the plants' colors, which neither the cyanotype nor any photographic process could reproduce. Whether blue, black, or brown, photography was for many decades a monochromatic (single-color) art.

Given these drawbacks, why did Anna choose photography? While Talbot's experiments had been motivated by his inability to draw, Anna clearly had the skills to accurately represent scientific specimens using a pencil. One perceived advantage of photographs was the widely held idea that they had been drawn by "nature itself," as if the sun, not the photographer, were the artist. Rather than represent an interpretation, photographic images were understood to be free from human intervention. Because of this, botanical photograms were seen not only as pictures of the plants but as stand-ins for the specimens themselves. The deep blue backgrounds of Anna's cyanotypes no doubt enhanced that impression, giving the sense that the seaweed still floated in the water. As a result, people considered photographs to be more truthful, even when they contained less information than a drawing would.

We still argue today about photography's relationship to truth. The roots of this debate, as well as many of our understandings about how photography works, are still tangled up with the qualities that were ascribed at its invention. Anna's decision to use photography for her project is as important for the ideas that were beginning to be associated with photography as it is for the pictures themselves.

A Quietly Radical Act

Anna's ambition was enormous. Her commitment to using photography systematically for botanical illustration, as well as the sheer number of prints she produced, sets her work apart from other early photography projects. Though she modestly stated that her books were intended for "botanical friends," the actual recipients who have so far been identified were among the most prestigious members of the scientific community. John Herschel got a copy, which Anna personally inscribed and dated. She also sent Talbot a large portion of her book. He returned the compliment by sending her a part of his own photographic book, *The Pencil of Nature*.

Anna's father sent many of the copies on her behalf, and he once again tapped his extensive network for her benefit. At least one copy bears an inscription "from Mrs. Atkins, with Mr. Children's Kind regards." Today it might seem unusual for the father of a married and obviously accomplished woman to be writing letters for her. Why didn't Anna send these herself? Again, the answer likely reflects gender conventions. Married women were expected to behave modestly and discreetly. Even women as clever and ambitious as Anna would not wish to display such qualities publicly. Anna and her proud father also sent copies to the prestigious Royal Society. Though they would not admit her as a member, they did receive and properly catalog her work.

We don't yet know how, but Anna's book also ended up in the collection of the Linnean Society, another all-male organization of which she could not be a member, as well as that of the Jardin des Plantes in Paris, where Lamarck had worked. There is no record of how many copies Anna made and distributed, but the fact that at least fourteen have survived intact, and that many of their owners donated them to scientific institutions, shows that many people recognized the importance of this work, even at the time.

Despite the magnitude of her achievement, Anna's gender still factored into the way her male contemporaries evaluated her work. One of the early recipients was Robert Hunt, a scientist now better remembered for having written one of the first histories of photography. He wrote to Herschel, "I have recently had some very friendly letters from Mr. Children whose daughter Mrs. Atkins is engaged in copying the Alga [*sic*] by your Cyanotype process—the effect is exceedingly pleasing." In 1848, Hunt wrote a two-part article in *The Art Union* about the applications of photography to the arts, in which he discussed the cyanotype process and mentioned Anna's photographs specifically. However, he could not keep himself from downplaying her achievement even as he praised her results:

> [*Cyanotypes*] *are so exceedingly simple, the results are so certain, the delineations so perfect, and the general character so interesting, that they recommend themselves particularly to ladies, and to those travellers who, although not able to bestow much attention or time on the subject, desire to obtain accurate representations of the botany of a district. We have seen specimens of the British Algae executed by a lady, by the Cyanotype process, that are remarkable for the extreme fidelity with which even the most attenuated tendrils of the marine plants are copied.*

Though the pictures were remarkable for their "extreme fidelity," Hunt claimed, the cyanotype process was so easy that even a "lady" or a tourist with little time or attention could execute it. As he stated, the chemical process was simple. But he seems to have failed to register the extent and ambition of Anna's efforts (or even mention her by name), even though he was among the book's first recipients and knew precisely who made it.

Thereza by John Dillwyn Llewelyn, 1853–56

Scientific Daughters
Breaking Boundaries

Anna was not the only woman whose achievements in science were helped by a father's encouragement. For the few women who contributed to botanical scholarship in a public way, the support and connections of their male family members were essential. One such young woman was Thereza Mary Dillwyn Llewelyn, the daughter and granddaughter of botanists. She became interested in science as a teenager, and her father encouraged her fascination with astronomy by building her an observatory as a birthday gift. Like Anna's father, Thereza's family also had intimate connections with the photographic community: William Henry Fox Talbot was her mother's cousin, and her aunt, Mary Dillwyn, is thought to be the first female photographer in Wales. Her father, John Dillwyn Llewelyn, also took up photography very early. He and Thereza collaborated on some successful experiments making photographs through their telescope, including an early image of the moon.

Like her father and grandfather, Thereza was interested in botany and assembled a sizable herbarium. Her father took this picture of Thereza at work, studying nature through her microscope. A decorative photogram border of plant specimens alludes to her scientific collection as well as the album-making techniques then popular with women. In 1857, Thereza broke gender boundaries when a botanical paper she wrote was read at the all-male Linnean Society, a first for a female author.

Such sexism pervades the history of photography. Well into the twentieth century, manufacturers sold photographic equipment and processes on the premise that "even a woman" could do it. Despite Hunt's disparaging remark, he unknowingly played an important role in ensuring Atkins's place in photographic history: it was his copy of *Photographs of British Algae* that William Lang Jr. bought and exhibited in 1889.

One more "botanical friend" who received Anna's cyanotypes was Sir William Hooker, who was now director of the Royal Botanic Gardens at Kew. He was already aware of Anna's herbarium, thanks to John George's earlier correspondence, and when several parts of *Photographs of British Algae* were ready, John George sent them to Hooker. The botanist must have been pleased, based on Anna's father's letter to him in 1845: "Mrs. Atkins is much gratified by your approbation of her little presents, for it is from herself that you receive it—I am only the channel of communication. She considers you as her tutor in Botany, as what little knowledge she possesses in the science, has been chiefly derived from your works."

By collecting seaweed specimens and distributing them among a botanical community—including as prominent a member as William Hooker—Anna was participating in a long-standing feminine practice. But she was also reinventing it. She pioneered the use of a new form of scientific illustration. Her use of photography also completely reimagined the exchange of scientific information by making it possible to share data with multiple recipients at the same time. It was a quietly radical act. The impact women's specimen collections had on botanical scholarship has not always been acknowledged or recognized. They amassed enormous bodies of data that are still useful to scientists today, but their contributions have not always been counted as "scientific work." Anna's book helps to change that.

A New Era for Photography

Eight years after she began the project, at the end of 1851, Anna completed and distributed Volume II of *Photographs of British Algae*. She must have learned a great deal while producing the first volume, and she chose to produce the second slightly differently. Instead of sending the work out in parts, this time Anna sent it in a single installment of 150 plates. She was also getting faster; the second volume took her considerably less time to produce. But even as she worked, photography was changing. No longer a brand-new medium, it was becoming more of an industry than a craft.

Industry was on everyone's mind in 1851. For five months of that year, London's Hyde Park was dominated by an enormous structure built of iron and glass that housed the Great Exhibition. Dreamed up by Queen Victoria's husband, Prince Albert, this colossal fair showcased technology from around the world. Six million people came (a great many by railway) to marvel at the steam engines and spinning machines, textiles and ceramics, firearms and prosthetic limbs.

The building itself was a feat of modern engineering. Its architect, Joseph Paxton, was a gardener who based his plans on the large greenhouse he had built for the Duke of Devonshire at Chatsworth. Paxton's ingenious design took full advantage of the new materials produced by the Industrial Revolution: a wrought-iron framework held more than sixty thousand mass-produced sheets of plate glass, earning it the

Interior of the Crystal Palace by John Jabez Edwin Mayall, 1851

The Crystal Palace was so grand that it enclosed several large trees that grew on the site. In this daguerreotype, the full-grown elm dramatically conveys the building's scale. Though the exhibition looks empty, it was probably full when this picture was made. Only people who were standing still were recorded during the long exposure time.

nickname the Crystal Palace. The fair's amenities were as modern as the architecture: visitors could drink carbonated beverages from novel glass "pop" bottles, and for the price of just one penny, they got a chance to try out the first public flushing toilet.

Anna, John Pelly, and their friends Anne and Henry were among the crowds who streamed into the exhibition. They stayed with John George at his apartment in Torrington Square and visited the fair numerous times. John George went too, but Anna noted that although he found the machinery engaging and visited that section several times, he was one of the very few in England to express little interest: "Whether the fatigue attendant on the 'World's Fair' prevented his enjoying it, or whether he doubted the real utility of it, or from both causes combined, his interest in this enormous collection of objects was not so great as that of many other, perhaps I might say of most other, persons." Queen Victoria was apparently one of those other persons; she visited the Great Exhibition thirty-four times.

As Anna wandered through the show, she must have been particularly interested in the sections that highlighted photography and photographic equipment among the era's great achievements. There were cases filled with daguerreotypes and photographs on paper, magic lantern slides and stereoviews, as well as new technologies for mass-reproducing photographs in print. Looking at the array of new cameras, printing frames, and lenses on display, she couldn't help but see the astonishing changes that had taken place since she began her own work. It was clear that the early experimental days of the medium were over. Even William Henry Fox Talbot recognized this event as a photographic milestone, writing, "Ever since the Great Exhibition I have felt that a new era had commenced for photography."

Spiraea aruncus
(Tyrol.)

Chapter Three

The Art of Science

"Mrs. Atkins Suffered Such Grief"

Shortly after completing the second volume of *Photographs of British Algae*, Anna suffered a tremendous blow. On January 1, 1852, her beloved father died. Of all the losses Anna had endured, this one was undoubtedly the greatest. She was fifty-two years old, and the two had lived together for almost her entire life. John George had been her loving parent, invested teacher, and greatest cheerleader at every turn.

At a friend's suggestion, Anna tried to cope with her grief by writing a memoir of her father's life. It would be a "tribute of deep respect and of affection to his Memory" to be privately published for their family and close friends. She paused her work on *Photographs of British Algae* and spent most of that year sorting through John George's papers and drafting his biography.

Writing the story of someone's life is a challenging task in the best of circumstances. Recording all of her father's ups and downs must have seemed almost impossible, even as it provided a welcome opportunity to reflect on the achievements of someone she loved so much. She described the bittersweet process as "the pleasing though mournful labour of recording the principal events in the chequered life of a beloved parent." It took Anna many months to organize her materials and set her thoughts into words. She recounted his experiences from birth to death, compiled a record of his scientific contributions, and sprinkled examples of his poetry throughout.

Once the manuscript was complete, Anna and John Pelly sent it off to be printed. She was exhausted by the work, and her husband had grown worried. He wrote to the publisher, "I wish you would be kind enough to let me know how long our work will be in progress. I am in no sort of haste but Mrs. Atkins suffered such grief . . . after her father's decease &c during the progress of the manuscript as to make me fear for her health."

Anna's book *A Memoir of J. G. Children, Esq.* was finally completed in March of 1853. It is a thoughtful, thorough, and largely unsentimental account. She did not

Spiraea arincus (Tyrol) from *Cyanotypes of British and Foreign Flowering Plants and Ferns* by Anna Atkins, 1854

wish to distract her readers with her own emotions, but her admiration for her subject shines through. On the very last page, Anna allowed a little of her own voice to enter the narrative and gave herself a moment to express her feelings:

> *I have endeavoured, as far as I could, . . . to keep my relationship to the dear subject of it out of sight, that I might avoid the intrusion of my own feelings. . . . As my father's biographer (if I may apply such a word to so slight a performance), I took up the pen; but, as his child, I must lay it down. To pass over . . . the gratitude I owe him for the watchful affection that never ceased from the hour of my birth until his own lamp of life went out—to fail to record how deep and sincere was the friendship between himself and my husband, . . . the blank he has left can never be wholly filled up till the hoped-for day of final reunion—to finish my self-appointed task without such a record, would ill agree with either my love or my regret for him.*

Just as she had done in *Photographs of British Algae*, she did not include her own name anywhere in the book. She signed the text simply "A. A."

Although Anna tried to downplay her relationship with her father in order to focus on his achievements, we can see their special bond clearly in the letters her husband wrote after John George's death. He vividly described the love between this father and daughter and conveyed the immeasurable impact his passing had on their lives. Writing to a friend, he stated, "Few can understand the cause of my Wife's deep grief . . . she has stood by her parent in all his trials in life and very bitter they were, she assisted him in all his pursuits and was ever on the watch to care for and please him." Besides the terrible loss of his love, company, and support, it must have been a tremendous disappointment to Anna that her father did not live to see and share in the joy of the completion of her great work.

Writing John George's memoir provided an outlet into which she could channel her grief, but it could not take it away entirely. Her husband tried to make her feel better by taking her traveling, but when that didn't work, he tried another tack. He asked Anna's closest friend, Anne Dixon, to come and stay with them. Anne spent much of 1852 at Halstead Place, and it seems that her loving company, as well as her assistance with the complex and emotional task of preparing the manuscript, helped to restore Anna's spirits.

Since John George had frequently served as a father figure to Anne while her own father was traveling with the military, she must have felt his loss almost as painfully as Anna did. Anna's husband had been friends with Anne's husband even before the latter's wedding, and their marriages had drawn their families even closer. The Children-Atkins-Dixon families regularly stayed at one another's homes and traveled together. John George's death left a great hole in all of their lives.

A Third and Final Volume

Anne stayed on at Halstead Place even after Anna completed the memoir. She was still living there a few months later when Anna found the strength to resume work on *Photographs of British Algae* and begin its third and final volume. Once again, she took up the delicate labor of making cyanotypes. She spread out broad, flat sheets of *Ulva latissima* and spongy antler-shaped fronds of *Codium tomentosum* on her prepared paper

At Ferring by unknown photographer, 1863

This is the only known picture of Anna's beloved friend Anne Austen Dixon, who poses with her husband, Henry, outside their home in Ferring.

and exposed them to the sun. As she had done so many times before, she developed the prints in clear, cool water and laid them out to dry. When they were ready, she sewed them together into books.

Anna produced this third volume more quickly than she had the previous ones. It took her only a year to produce the fifty-three new plates and an additional group of forty-five replacements for plates sent in earlier installments. This may be because the third volume was smaller than the other two. She also may have had help: perhaps Anna asked Anne to assist her on the production line. Or maybe Anna was simply more efficient now, having had so much practice. In any case, each copy of her third and final volume contained nearly one hundred individual photographic images. She sent them out in the fall of 1853, almost exactly ten years after she had begun.

Anna must have felt an extraordinary sense of accomplishment. She had illustrated a majority of the seaweeds listed in Harvey's reference manual, and each of her three-volume sets contained around four hundred cyanotype prints, made one at a time, by hand. It had taken a decade, but Anna had achieved the goal she set out in the introduction to Volume I: "to obtain impressions of the plants themselves."

Even as she proudly sent off this third and final chapter, Anna knew she might need to continue working on it in the future. She had done her best to get a sample of each type of seaweed Harvey described, but there were a still a few gaps in her book where she had been unable to find a good specimen or, in a few cases, any specimen at all.

Vaucheria dichotoma.

Rivularia nitida.

Ulva latissima.

Codium tomentosum.

Along with the table of contents for Volume III and a list of errata (corrections to mistakes in the earlier volumes), she included an appendix in this final mailing, in which she wrote a notice to the reader: "Should any of the plants which are omitted, or of which the impressions are from poor specimens, be obtained, a supplementary part may at some future time, be added to this work." She signed it with her customary "A. A." and added "H. P. Sept. 1853" to indicate the work had been done at Halstead Place.

As it turns out, this was indeed the end of Anna's work on seaweed. It does not appear that she ever decided to make any of the corrections or additions she mentioned in her appendix. After sending out Volume III, she put the project aside.

Anna's Gift

Anna did not rest for long. Just one year later, she gave Anne a beautiful gift: another album of cyanotypes. Though she used the same process, this new book looked rather different. The format was larger, and Anna had mounted the cyanotypes to paper (sometimes more than one to a page) before having them bound into a book. But the most noticeable difference was its subject matter. Shifting gears, she turned her attention to ferns and flowers collected in the British Isles and all over the globe. She titled the book *Cyanotypes of British and Foreign Flowering Plants and Ferns*.

This time, she was not following anyone else's list. She could indulge her own tastes and imagination. Anna chose species ranging from the most exotic foreign blooms to the homeliest of British weeds. She made cyanotypes of trilliums and Indian cucumbers from Maine and feathery spiraea from the Tyrolean Alps. She showed off the translucent petals of an Oriental poppy, probably cultivated in an English greenhouse, and celebrated a bunch of common dandelions that could have been picked in any British meadow. Her choice of ferns similarly spanned the globe. In addition to a wide variety of native British species, she selected examples from New Jersey, Australia, and Jamaica.

The process for making these prints was just as before. As with *Photographs of British Algae*, Anna used actual specimens. Once again, the plants came from such a vast geographic area that there is no way she could have gathered all of them herself. She must have relied on her network of botanical friends to lend her samples that would round out her own collection. In total, she made cyanotypes of more than 160 types of ferns and flowering plants for this album.

Top left: *Vaucheria dichotoma* from *Photographs of British Algae: Cyanotype Impressions* (Vol. III) by Anna Atkins, 1853

Top right: *Rivularia nitida* from *Photographs of British Algae: Cyanotype Impressions* (Vol. III) by Anna Atkins, 1853

Bottom left: *Ulva latissima* from *Photographs of British Algae: Cyanotype Impressions* (Vol. III) by Anna Atkins, 1853

Bottom right: *Codium tomentosum* from *Photographs of British Algae: Cyanotype Impressions* (Vol. III) by Anna Atkins, 1853

One thing, however, had changed: she only needed to make one image of each plant. This new book was one of a kind because it was intended for a single recipient. She still gave each specimen its own plate and labeled it with its Latin name, but this time, in most cases, she noted where the plant had been collected. (This information was always included in herbaria, but for some reason Anna had left it out of *Photographs of British Algae*.) As far as we know, she did not include any other writing in this album; it was clearly meant to be a picture book.

Anna organized the plates into four categories: British Flowering Plants, Foreign Flowering Plants, British Ferns, and Foreign Ferns. She introduced each section with a title page, just as she had done for each volume of *Photographs of British Algae*. But this time,

The Art of Science 75

Anna used a far more elaborate and exuberant style. On two of the title pages, she scattered a variety of flowering plants almost chaotically across the paper, as if across a field or forest floor, emphasizing their different shapes. On the other two, she neatly arranged lacy fern fronds into elegant wreaths to encircle her handwritten titles. Like the title pages from *Photographs of British Algae,* the design of these pages clearly borrows from techniques widely used in women's scrapbooks, as well as the style common in popular books on botany. While Anna had indulged a little bit of whimsy on the title pages of *Photographs of British Algae*, here she gave full rein to her creativity. When she had finished the plates and title pages, she mounted them to larger sheets of thick paper. She had them bound together in leather and the book's cover stamped in gold with their initials and the date: "A. A. to A. D. 1854."

A Tangled Tale

We don't know as much as we should about Anna's gift album. For many years, few people even knew it existed. Until well into the twentieth century, scholars thought *Photographs of British Algae* was her only photographic work. But in the 1970s and 1980s, historians became interested in photography's beginnings, including Anna's work. Collectors began looking seriously at early photographs, and more of this material came up for sale to meet this new demand. Many of these photographs (along with the photographers who made them) had been all but forgotten. Some had been stored away in family homes, and others had simply been overlooked.

In 1981, the album Anna gave to Anne was found in a private collection and sold at auction. Though its discovery offered a new perspective on Anna's work, the details of why she made it, and where it had been, were still unknown. More information was lost when the winning bidder took the album apart, threw away the binding, and sold off the pages as individual artworks without making an inventory of its contents. (This practice of "disbinding" albums for sale is fortunately far less common today than it used to be.) It is impossible to reconstruct a full list of the pictures Anna included. A significant number of the individual pages have since been located, so we can piece together a good sense of her album's contents as well as its beauty and vibrancy. Nonetheless, many questions remain.

When two more albums of fern cyanotypes were discovered in the years following the auction, the questions only grew. Taken together, these albums offered rich proof that Anna continued to work seriously in photography but that her interest had expanded beyond scientific illustration. They also showed that her audience had shifted: these albums were for personal ends and private consumption. The intention behind them is harder to discern than it is for *Photographs of British Algae,* where her goals and audience were clearly defined. These new books seemed to do something different, bridging the realms of scientific documentation and personal expression. Equally important, they offer evidence that Anna was no longer working alone.

While they provided new information about the direction of Anna's later work, these more recently discovered albums also complicated the story. There are many overlaps between them and

Top left: *Avena novae villiae* from *Cyanotypes of British and Foreign Flowering Plants and Ferns* by Anna Atkins, about 1854

Top right: *Gleichenia flabellata* from *Cyanotypes of British and Foreign Flowering Plants and Ferns* by Anna Atkins, about 1854

Bottom left: *Lycopodium (Ceylon)* from *Cyanotypes of British and Foreign Flowering Plants and Ferns* by Anna Atkins, about 1854

Bottom right: *Lygodion-volubile* from *Cyanotypes of British and Foreign Flowering Plants and Ferns* by Anna Atkins, about 1854

The Art of Science 77

Section title page from *Cyanotypes of British and Foreign Flowering Plants and Ferns* by Anna Atkins, about 1854

Cyanotypes of British and Foreign Flowering Plants and Ferns. They were similarly titled—the new albums were both called *Cyanotypes of British and Foreign Ferns*—and all three had a common subject and style. There was one peculiar difference: the initials stamped on the covers indicate that *Anne* had been the one to give them as gifts. She gave one to her nephew, Henry Dixon, and stamped the cover in gilt: "A. D. to H. D." She gave the other to someone with the initials "C. S. A." (who still has not been identified) and marked the cover in the same style. Even more puzzling, she had given these books in 1853, a year *before* Anna gave her very similar album to Anne.

The inscription Anna put on the cover of the book she gave Anne ("A. A. to A. D.") suggests that she was its sole author. But comparing this album to the two fern albums given by Anne in 1853 complicates this explanation. It is not out of the question that Anna's gift was to commemorate work they did together. We know that both women were making cyanotypes at this time: Anne had begun to produce her own cyanotype pictures during her stay at Halstead Place. She probably used some of Anna's paper to produce them. (Like many early photographers, Anna used a particular brand of writing paper for her prints: J. Whatman's Turkey Mill. Her choice was a lucky one; Whatman watermarked his papers with the year they were manufactured, so the marks on the paper have helped historians assign dates to photographs and reconstruct the order in which they were made.) Some historians have suggested that Anne may have played a role in making the final volume of Anna's seaweed project. But how they actually worked together remains a mystery.

The nature of their partnership becomes even harder to unravel when we look at the overlaps across the three books. Anne's albums also included beautiful title pages and section titles that combine photograms of plants and handwritten text. Comparing these pages reveals that the decorative penmanship is the same, and that they were probably made by reusing the same pieces of oiled paper. Also, the pages use the same plant specimens, just in different arrangements. This suggests that the pages for all

Section title page from *Cyanotypes of British and Foreign Flowering Plants and Ferns* by Anna Atkins, 1854

Anna's title pages for each section of *Cyanotypes of British and Foreign Flowering Plants and Ferns* combine specimens with beautifully handwritten text. The arrangement on each page varies from scattered riotously to elegantly composed.

Title page from *An Analysis of the British Ferns and Their Allies* by G. W. Francis, 1842

Anna was clearly inspired by the style frequently used in books on ferns. In this example, the illustrator has used the fern fronds to set off the title, just as Anna did in *Cyanotypes of British and Foreign Flowering Plants and Ferns*.

three albums were made at the same time, even if they were given in different years. Maybe Anne and Anna were working independently on the same subject, but side by side. It seems more likely, however, that the two collaborated. The album Anne gave to her nephew, for example, has labels in at least three different people's handwriting, one of which is clearly Anna's. Did the two women divide up the work? Did they swap prints? Or did they make their decisions together? It is impossible to know.

The most significant difference between the three books is that the album Anna gave to Anne is considerably larger in format and broader in content. It includes a section on flowering plants, whereas the earlier two focus exclusively on ferns. Given the features the three albums share, it seems reasonable to conclude that the two earlier fern books—or at least the cyanotypes they contain—were produced by both women, even though Anne seems to have made the gifts alone.

Asplenium ruta muraria, British from *Cyanotypes of British and Foreign Ferns* by Anna Atkins and Anne Dixon, 1853

Though these three albums in some ways resemble Anna's book on seaweed—the fern specimens are sorted into categories and labeled with their Latin names—they seem more closely related to the kinds of botanical work traditionally done by women in the privacy of their homes. Anne and Anna's unique fern albums were not part of a broad exchange of scientific information; they are records of an interest they shared with countless British women and were given as gifts to people they loved. Because these books belong to the intimate domain of sentiment and female friendship, their stories are much harder to excavate from the past.

If we can't determine who made which individual picture, at least we can be certain of one thing: Anna now had a new partner in photography. With the death of her father, she was undoubtedly grateful for Anne's companionship. Her presence also seems to have allowed Anna to find a new way of working: though John George had enthusiastically encouraged and promoted Anna's photography, Anne was a hands-on participant.

Fern Fever

Anna and Anne's new subject matter reflected not only their own interests but also a growing fascination with ferns that evolved into a full-fledged craze. Like seaweed, ferns reproduced asexually, and scientists had little studied or understood them as a result. That began to change in the 1840s. While botanists had previously thought there were only fifty species native to Great Britain, they now discovered that those species produced an enormous number of variations, and they were curious to understand how. They supplemented their research on domestic ferns with a constant stream of specimens that arrived from the farthest reaches of the empire.

Amateur botanists and gardeners were even more obsessed with ferns than the scientists were. While it might be difficult today to imagine fern-collecting as a thrilling activity, it was hugely popular for half a century. Part of its appeal was location: ferns grew in damp wooded glens, far from the hustle and bustle of the city. Just as city dwellers escaped to the seaside to collect seaweed and seashells, they also traveled to the wild and rugged countryside to study and collect ferns. Fern-collecting was also a social activity. Women organized picnics and tea parties in the woods, and some Victorians even found that these out-of-the-way places offered rare opportunities for men and women to mingle informally (and unchaperoned).

Anna and Anne joined the crowds of amateur "trippers," as they were called, who tromped into the English woods in Devon, or even farther away in Scotland on the hunt for plants. Though Anna lived on a gracious estate in Kent, and Anne in a vicarage in Sussex (rather than dirty urban London), they still enjoyed excursions in nature. They packed narrow shovels called fern trowels for digging up the plants by the roots and carried a box or basket lined with wet cloth to keep the specimens moist. Guidebooks like Edward Newman's *History of British Ferns* (1840) encouraged urban Britons to try growing ferns at home in glass boxes called Wardian cases, and to bring "the loveliest scenery of nature into the most crowded streets of our sooty and muddy metropolis." Others taught collectors how to dry their specimens and glue them into "fern books." Anna and Anne took this activity into new territory, using their own dried, pressed ferns to make cyanotypes instead.

Adiantum assimile

*Asplenium ebeneum
New Jersey*

*Polypodium pinnatum, or
"Tree Fern"
(Jamaica)
grows by a simple stem to the
height of 20 or 25 feet*

Ceylon

Top left: *Adiantum assimile* from *Cyanotypes of British and Foreign Ferns* by Anna Atkins and Anne Dixon, 1853

Top right: *Asplenium ebenum, New Jersey* from *Cyanotypes of British and Foreign Ferns* by Anna Atkins and Anne Dixon, 1853

Bottom left: *Polypodium pinnatum, Jamaica* from *Cyanotypes of British and Foreign Ferns* by Anna Atkins and Anne Dixon, 1853

Bottom right: *Ceylon* from *Cyanotypes of British and Foreign Ferns* by Anna Atkins and Anne Dixon, 1853

Fern-collecting, like sea-weeding, was especially popular among women. In addition to fern books, they made decorative scrapbooks and even used the plants as stencils for splatter-painting. Later, as photography became easier and more widely practiced, they sometimes made photograms much like Anna's and Anne's, which they incorporated into other kinds of picture books, including photographic albums. Fern patterns soon covered every imaginable surface, from vases to wallpaper to carpets. They adorned dresses and jewelry and park benches. Even the design still on top of the popular British cookies called "custard creams" was patterned on ferns. The passion reached such heights that the naturalist and clergyman Charles Kingsley felt compelled to give it a name: "pteridomania," or "fern fever":

Your daughters, perhaps, have been seized with the prevailing 'Pteridomania,' and are collecting and buying ferns, with Ward's cases wherein to keep them (for which you have to pay), and wrangling over unpronounceable names of species (which seem to be different in each new Fern-book that they buy), till the Pteridomania seems to you somewhat of a bore: and yet you cannot deny that they find an enjoyment in it, and are more active, more cheerful, more self-forgetful over it, than they would have been over novels and gossip, crochet and Berlin-wool.

Even though Kingsley thought the love of fern-collecting had become rather extreme, he did see the hobby's benefit as a wholesome alternative to "novels and gossip." He also felt that the new taste for decorating parlors with living ferns was a vast improvement over the "fancy work" that often cluttered Victorian homes. "Fancy work" was a way of describing the many crafts with which women filled their leisure time: making wax fruit and flowers, covering screens with feathers, and doing needlework (including the popular style called "Berlin work"). Few surfaces in the Victorian parlor escaped embellishment. In addition to ferns, women used lace, leather, shells, dried flowers, pinecones, and even human hair to make elaborate decorations.

This mania for ferns did not completely disappear until the beginning of World War I. Though it fostered an appreciation for nature, the activity also had serious environmental consequences. British fern collectors were so enthusiastic that several types were on the verge of disappearing. Their impact alarmed some people enough to suggest laws to protect the ferns, much like the ones that protected animals from hunting. Commercial fern nurseries did even more damage, wiping out complete species as they gathered wild plants to cultivate and sell to eager urban gardeners.

Kate Dore by Julia Margaret Cameron and O. G. Rejlander, about 1864

Julia Margaret Cameron laid fern fronds over a negative and exposed them together to create this layered image. Though she became a famous photographer herself, she had not yet learned to use a camera. This portrait of Kate Dore, a member of Cameron's household, was probably taken by the renowned photographer O. G. Rejlander.

The Art of Science

Advertisement for Wardian cases by Dick Radclyffe and Co., 1856

Technology in the Garden

Britons were passionate about gardening. Once only an aristocratic hobby, by the nineteenth century the middle classes were eagerly taking it up, even in the city. But ferns were almost impossible to grow. Their system of reproduction was poorly understood, and they required very specific conditions to thrive.

This changed in the late 1830s, when the medical doctor and urban gardener Nathaniel Bagshaw Ward began promoting a glass box he called a "Wardian case." Ward was frustrated by the way London's pollution made it difficult to raise healthy plants. He discovered that a glassed-in box could protect his garden from sooty air and provide the proper levels of humidity, light, and heat needed to cultivate finicky ferns.

In 1845, the government repealed a sales tax on glass, making the expensive material much more affordable. Almost immediately, Wardian cases were manufactured and sold in enormous quantities. Advertisements ran in all the papers, and the boxes seemed to appear in every middle-class parlor. Wealthy households built "ferneries" (very large versions of the Wardian case) complete with rock grottoes and waterfalls, and people incorporated them into botanic gardens, tea gardens, and even theaters.

This new technology was also responsible for a large-scale globalization of botany. Traveling versions of the Wardian case made it feasible to bring back live specimens from all over the world for study, cultivation, and display in England. They had a major impact on commerce too. British traders used glass cases to steal and transplant the seedlings of tea bushes from China to India, thus establishing the Indian tea industry from which the British earned an enormous fortune.

Anna and Anne's fern albums contain specimens they likely collected themselves in England, Ireland, and Scotland. They no doubt received others through exchange with members of the Botanical Society or from John Pelly's extensive network of contacts. Anna's 1854 album includes at least one fern from the famous conservatory (greenhouse) of the Duke of Devonshire at Chatsworth. While the "foreign" sections of their albums contain examples from Ceylon, Australia, and the United States, the majority of foreign ferns came from Jamaica, very likely from the Atkins family's coffee plantations or through their business connections in the West Indies. The fern albums reflect the same cultural forces that shaped the rest of Victorian England: changes in travel, an interest in botany, the overwhelming passion of British women for ferns, and the increasingly global nature of scientific exchange and commerce.

A Shift of Perspective

When they were both sixty-two years old, the women made one last book, titled simply *Cyanotypes*. This final album, made nearly a decade after the three albums of ferns, makes the shift in their work from science to art, and from public to private, even more apparent.

Nearly twenty years had elapsed since John Herschel had invented the cyanotype and Anna had bravely begun a book illustrated entirely by the brand-new process. Anna and Anne now used photography not because it was radically experimental but because it was familiar. It was also undeniably beautiful. Anne gave this last album to her nephew in the summer of 1861, her second such gift to Henry. She must have known he would appreciate her efforts; in the years since her first gift, he himself had become an accomplished photographer. While serving in the East India Company, Henry had made hundreds of photographs, and his work was exhibited in both India and London. He was also working with cutting-edge photographic technology. The same year Anne gave him *Cyanotypes*, Henry patented a new kind of negative.

This final album is the most unusual of all the books the women made, and its purpose the hardest to pin down. Although it curiously includes some of the published plates from *Photographs of British Algae*, it has no clear scientific motive or organizing theme. In fact, the majority of the seventy-four cyanotypes seem to have been made for pure visual pleasure. Anna and Anne made pictures from grasses, flowers, scraps of lace, and feathers ranging from chicken to peacock. Most of these objects seem to have been chosen for their bold shapes in silhouette. The women labeled each subject, but they used the common names of the plants and birds more often than their two-part Latin names, further proof that this was a personal project instead of a scientific one. The pictures are ethereal, bold, graceful, and joyous, and they play with patterns and compositions more freely than any of their previous work did. Given their long history of collaboration, we could safely conclude that this was their last joint project. The style of some of these pictures is so different from anything the two produced before, however, that it leaves open the question of whether Anne might have made these newest cyanotypes on her own.

Top left: *Papaver rhoeas* from *Cyanotypes* by Anna Atkins and Anne Dixon, 1861

Top right: *Peacock* from *Cyanotypes* by Anna Atkins and Anne Dixon, 1861

Bottom left: *Clematis vitalba* from *Cyanotypes* by Anna Atkins and Anne Dixon, 1861

Bottom right: *Specimens of Grasses* from *Cyanotypes* by Anna Atkins and Anne Dixon, 1861

Portrait of Anna Atkins by unknown photographer, early 1860s

Anna stood for this photograph when she was about sixty years old. By that time, photography, particularly portraiture, had changed enormously. For much of history, only the wealthy had their portraits made. By the 1860s, almost anyone could afford to get their picture taken, and hundreds of studios offered small portraits like this one called *cartes de visite*.

A Final Photograph

Around the time of this last album, Anna went to a photography studio to have her portrait taken. Wearing a lace cap and a striped dress with a full skirt, she stood with her hand on the back of a chair, looking off to the side as if lost in thought. For a woman who was so perceptive about the uses of photography from the moment of its invention, and so committed to applying it to a major publication, it seems ironic that this is the only photographic portrait of her that has ever been found. But this picture also reminds us just how much photography had changed from that day in 1841 when Anna got her camera and she and her father tried unsuccessfully to make a portrait. This new style of portrait was called a "carte de visite" because it mimicked the size and shape of the small calling cards people left at friends' homes when they came to visit. Invented in 1854 by the French photographer André Adolphe-Eugène Disdéri, the photographs were made using a multi-lens camera that let the photographer shoot several frames on a single negative.

Inexpensively priced, cartes de visite transformed how people used photography. In an explosion of "cartomania," millions of these photographs were mass-produced and exchanged in the second half of the century. People also avidly collected and traded images of celebrities, from actresses to writers to the queen herself. Only twenty years earlier, Anna had needed a decade to make thousands of photographs, one at a time, in a labor-intensive process. Her vision of photography, so revolutionary for its day, had now been completely eclipsed by manufacture and distribution on an industrial scale.

A few years after Anna stood for this portrait, in 1865, her beloved friend Anne died of cancer. Though there is no record of Anna's feelings, she must have been devastated by the loss. That same year, she donated her herbarium, which now contained approximately fifteen hundred specimens, to the British Museum. (The museum's natural history division later became a separate institution, the Natural History Museum.) While many sheets from her herbarium are mixed with the rest of the museum's collection and can no longer be identified, others are stamped in ink: "Mrs. Atkins' Herbarium." Perhaps Anna no longer wanted to pursue the activity without Anne. Or maybe she simply felt too ill to continue building her collection. Now well into her sixties, she began to suffer a long period of poor health.

Anna Atkins died at Halstead Place on June 9, 1871, at the age of seventy-two. Although she had been sick for some time, the official cause of death was listed as "paralysis, rheumatism, and exhaustion." It is hard to know what this diagnosis would correspond to in modern medical terms, but it could simply be the effects of old age. Seventy-two was considered a life fully lived at that time. A long, rich life was another thing Anna shared with her father; she was the same age he was when he died.

Anna's husband, John Pelly, who had also been in poor health, died only a year later. The two were buried side by side in the churchyard of St. Margaret, the parish church at Halstead Place, though sadly neither the church nor the great house is still standing. Though a commemorative plaque that honors her extraordinary work in photography was added to her home's former gatehouse in the 1990s, Anna's simple headstone tells us a great deal more about what was important to her. Placed next to her husband's, it reads, "Anna his wife, only child of John George Children. She died 9 June 1871 aged 72." These words reflect both the gender conventions of her time and the intensity of her relationships. A devoted wife to John Pelly, she was also her father's daughter to the very end.

Public Recognition and Private Lives

Historians often tell the stories of exceptional individuals and their singular achievements. This was especially true during Anna's lifetime. Victorians were obsessed with heroes and hero worship, but the modern heroes they celebrated were almost exclusively men. By contrast, women in the Victorian era achieved distinction precisely by remaining undistinguished, quietly cultivating moral uprightness and family values within the home. Even Queen Victoria was as revered for being a devoted wife and the mother of nine children as she was for reigning over the largest global empire in human history.

Work Outside the Home

Anna left no record of her feelings about the ways her gender affected what activities she could and could not participate in, but at least one of her close friends, Caroline Cornwallis, was an outspoken advocate for women's equality. Although they wrote many letters to each other, they most often discussed questions of religion. We don't know if Anna shared Caroline's views, but she certainly must have been aware of them.

Women who worked outside the home in any kind of profession were so unusual in Victorian England that we still easily recognize many of their names. One pioneer who was quite vocal about her thoughts was Florence Nightingale, whose name is now immediately associated with nursing. Born in 1820 to a wealthy English family, she learned philosophy, Greek, and Latin. She was also a gifted mathematician. Despite her education and talents, her family still expected she would marry a rich man, have children, and live a life of genteel leisure. She would run her household, tend to the moral education of her children, and participate in society through charitable work or culture. Nightingale had no interest in this path, hated parties, and refused to marry. She sarcastically described the pointlessness of a woman's life by recounting how her sister and mother spent their days: "The whole occupation of Parthe and Mama was to lie on two sofas and tell one another not to get tired by putting flowers into water."

Nightingale's writings are full of longing for "a profession, a trade, a necessary occupation, something to fill and employ all my faculties." She was keenly interested in medicine, and, against much resistance from her family, pursued a career in nursing. Until that time, women were considered so biologically nurturing that nursing was thought to require no formal training. But at the age of thirty, she traveled to Germany to study and then famously served as a nurse in the Crimean War. The soldiers nicknamed her "the Lady with the Lamp," as she walked in the darkness among their hospital beds. Nightingale became a celebrity for her work during the war. In 1860, she founded her own school, turning nursing into a highly trained professional occupation for women.

Portrait of Florence Nightingale by Henry Hering, 1856–57

The great danger of this traditional approach to history writing is that it presents an incomplete picture of the past. By focusing only on the achievements of public figures, it ignores the rich complexity of women's private lives. Anna Atkins was a trailblazer. She was quick to identify photography's potential contribution to scientific illustration and to recognize its usefulness to the exchange of ideas and information that became central to the practice of modern science. She was among the very first to imagine and execute a publication that exploited photography's specific properties. In publishing *Photographs of British Algae* so early, she even beat out William Henry Fox Talbot, the man who invented photography in England. But perhaps her real achievement lies in the way she simultaneously worked within and pushed against the considerable weight of gender-based expectations.

In a funny way, Anna's publicly recognized contribution to photography also helps enlarge our understanding of women's private lives. From 1843 to 1853, she worked to create a book that was placed directly into the hands of Britain's scientific heroes and all-male elite associations. Over the course of the following century, *Photographs of British Algae* found its way into the collections of the British Library; the Royal Botanic Gardens, Kew; and the Linnean Society, among others. For her pioneering and imaginative contribution to the development of photography (and thanks to the persistence of the nineteenth-century book collector William Lang Jr., who tracked down the work and the identity of the mysterious "A. A."), Anna Atkins will be forever remembered.

Yet her work on *Photographs of British Algae* has had an equally important, if unintended, consequence. As interest in its maker grew, the private albums, as well as the friendship of Anna and Anne, were also brought forward. It was a body of work and a relationship that might otherwise never have been discovered or recognized. Although she dedicated every copy of *Photographs of British Algae* publicly to her father, Anna made only one album purely as a gift, and it was for her lifelong friend Anne. The albums they made together help illuminate a world of women that is far more difficult to access than that of Victorian men. Anna and Anne's fruitful collaboration reminds us that although women were largely excluded from the public activities of men, they built their own private networks of exchange: social circles, clubs, families, and intimate friendships. Their achievements, though often undocumented, are equally worthy of celebration. No doubt there are many more such stories waiting to be uncovered and told.

Papaver rhoeas from *Cyanotypes* by Anna Atkins and Anne Dixon, 1861

Cypripedium
Portland — U.

Epilogue

The Cyanotype as Contemporary Art

Though the cyanotype process is nearly two hundred years old, it is widely used by contemporary artists. This was not always the case. For one hundred years after Atkins's publication, very few artists made cyanotypes. During most of the nineteenth century, cyanotypes, or blueprints, were used only to reproduce technical drawings, mainly in the fields of architecture and engineering. They were also used as a form of craft: manufacturers realized that because the process was so simple, they could mass-produce cyanotype paper and market it to amateurs, especially women. Making cyanotypes did not require any technical know-how or special equipment, only access to sunlight and running water. As cyanotypes became increasingly associated with architects and engineers (or worse, amateurs and female crafters), photographers who considered themselves serious artists largely shunned the process. Artists today appreciate the prints' bright blue color as one of its most appealing characteristics, but late nineteenth-century critics viewed it as inappropriate for art. As Peter Henry Emerson, a photographer and opinionated photography theorist, wrote in 1889, "Blueprints are only for plans, not for pictures."

This attitude began to change in the second half of the twentieth century, likely due in part to the widespread acceptance of color photography. More and more artists also began incorporating photography into their work, and they were far less concerned with its "rules" than earlier artists had been. In fact, many who choose to use the cyanotype today celebrate the very qualities that earlier critics looked down upon. Francesca Woodman (American, 1958–1981), for example, looked to the blueprint's use in architecture and used a commercial machine to produce large-scale, architecturally inspired prints. Though she is best known for her small, poetic, black-and-white self-portraits, after she graduated from the Rhode Island School of Design in 1978 and moved to New York City, she began experimenting with diazotypes. This type of print closely resembles the cyanotype but is made on a machine, without water, and is still widely used for reproducing architectural floor plans.

Cypripedium (Portland U.S.) from Cyanotypes of British and Foreign Flowering Plants and Ferns by Anna Atkins, 1854

Untitled by Francesca Woodman, 1980

Blueprint for a Temple (I) by Francesca Woodman, 1980

For her most ambitious project, Woodman photographed herself and friends wrapped in sheets and posing as caryatids, carved female figures that were used as supporting columns in Greek and Roman classical architecture. Woodman projected her images on long scrolls of special light-sensitive paper and then processed them at a printing shop, creating prints far larger than she could have managed in a traditional darkroom. She combined twenty-nine of these prints into an immense collage measuring fifteen feet tall and ten feet wide that she titled *Blueprint for a Temple (I)* (1980). Five caryatids, lined up in a row, support its architectural structure. (If you look closely, you will recognize details of ordinary bathroom tile patterns and the claw-feet of a bathtub.) Woodman wanted to break away from the intimate scale and personal subject matter of her earlier photography and was also inspired by the long periods of time she had spent in Italy, both as a child and as a student. In *Blueprint for a Temple (I)*, she created a monumental artwork that draws connections between the real and the imaginary, the domestic and the sacred, and the classical past and her own contemporary experience.

Littoral Drift Nearshore #765 by Meghann Riepenhoff, 2017

If Woodman drew upon the blueprint's historically technical uses, Meghann Riepenhoff (American, born 1979) expands upon the cyanotype's connections to nature. Like Atkins's seaweed studies, Riepenhoff's explorations of the cyanotype process are inspired by the sea itself. Sitting in her California studio overlooking the Pacific Ocean, she became mesmerized by the constantly changing shoreline as the tides moved in and out. She wondered if there was a way to document this phenomenon, not by photographing it with a camera but by allowing the waves to record

themselves on photographic paper. Using essentially the same formula Atkins employed more than 175 years earlier, Riepenhoff mixes her own chemistry and applies it by hand to large pieces of paper. She plunges these light-sensitive sheets of paper into the ocean and allows the movement of the waves and currents to batter the paper, and the sunlight to expose it. The results are deliberately unpredictable, affected by the force of the waves themselves, the strength of the sun, the temperature of the air, and even the chemical quality of the water. These variables produce a startling array of colors: the full range of blues, from saturated cobalt to the palest of skies, but also—quite surprisingly—sulfur yellow, burnt orange, pale green, and brown. The marks on the paper are the shadows of the water passing over it and the trails of chemistry washing away. Riepenhoff describes her process as a "collaboration" with nature: the shoreline not only is the subject of these photographs; it also helps to make its own picture.

Atkins chose the cyanotype process partly because she hoped her pictures would be permanent, but Riepenhoff chooses not to wash, or "fix," her prints. Under certain circumstances, such as strong sunlight, these prints are likely to fade or change color. Though directly inspired by Atkins's early experiments, Riepenhoff's conclusions are ultimately quite different. If Atkins used the cyanotype to record, categorize, and organize nature so that we might better understand it, Riepenhoff's sublime abstractions demonstrate that despite our mightiest efforts, the forces of nature cannot be tamed.

Multimedia artist Andrea Chung (American, born 1978) looks at the intersection between the cyanotype's connections with the blueprint and the natural world. What results is a pointed critique of the environmental and human costs of colonialism. In her photography, Chung uses the lionfish as a symbol of the complex effects of European empire-building in the Caribbean in the eighteenth and nineteenth centuries. Her work considers not just the history of colonialism but also the way imperialist attitudes continue to impact people's lives and livelihoods. The strikingly beautiful but venomous lionfish is native to the warm waters of the South Pacific and Indian Oceans, but in the 1980s scientists began detecting large and growing populations in the Caribbean Sea and Atlantic Ocean. This was likely a result of escapes or releases from collectors' fish tanks. Without local predators, the transplanted lionfish have rapidly multiplied, wiping out the food supply of native fish and nearly destroying coral reef ecosystems. As an invasive, non-native species, Chung sees the lionfish as a powerful and ambiguous symbol that could stand in for the colonists who exploited the area's resources and populations, or for the people brought to the New World against their will, doing their utmost to survive—or both.

Using photographs she finds on the internet, Chung arranges the fish in patterns that recall traditional military formations, positioning them as if they are going into battle. Chung plays on this symbolism, as well as that of the cyanotype process: its blue evokes the depths of the ocean while also recalling the kind of blueprint, or planning, required to support a massive program of European expansion. The series reminds us that the nineteenth-century scientific efforts to chart, document, and collect the natural specimens of the world were closely tied to the violent colonization of peoples and resources.

Untitled from the series *Anthropocene* by Andrea Chung, 2016

 The three women discussed here represent only a sampling of the contemporary artists who have found new life in an old technique. Their work demonstrates that this deceptively simple process can generate complex ideas. Whether drawn to its connection to the very earliest days of photography or curious about its changing uses and meanings over time, contemporary artists who use the cyanotype are also deeply engaged with photographs as physical objects. Today we snap unimaginable quantities of photographs and share them with a single click, so it makes sense that these artists might reach back to a moment when photography was a slower, more hands-on undertaking.

 Anna Atkins would hardly recognize photography as we practice it today. Though her project might now seem old-fashioned, it is worth remembering that she was using cutting-edge technology to invent a radical new way of sharing her ideas. The artists who currently use her process are not only tapping into the powerful results of a simple combination of light, chemistry, and water; they are also rediscovering the endless possibilities that characterized photography from the very beginning.

Glossary

algae (n): (plural of alga) a group of non-flowering, mostly aquatic plants, including seaweed

algologist (n): a person who studies the science of algae, now usually called a phycologist

amateur (n): a person who engages in a pursuit, study, science, or sport as a pastime rather than as a profession

anonymous (adj): of unknown authorship or origin; not named or identified

antiquities (n): relics or monuments from ancient times

aperture (n): an opening

botanical (adj): having to do with **botany**; derived from plants

botany (n): the branch of biology dealing with plant life

calotype (n): an early photographic process that resulted in a paper negative from which multiple positive prints could be produced, invented by William Henry Fox Talbot in 1841

camera obscura (n): a darkened enclosure with a small opening (sometimes fitted with a lens) through which light enters to project an image onto the opposite surface

carte de visite (n): a small photographic portrait used as a visiting card

cobalt (n): a metallic element used to make the **pigment** cobalt blue; a bright blue color

colonialism (n): a form of **imperialism** in which a country establishes colonies to exploit their resources and build its own political power

conchology (n): the study of **mollusk** shells

confervae (n): (plural of conferva) thread-like **algae** found in still, fresh water

cyanotype (n): an early photographic process that produced a blue-and-white print, sometimes called a blueprint

daguerreotype (n): a very early photographic process that produced a unique positive image on a polished metal plate, invented by Louis-Jacques-Mandé Daguerre in 1839

diazotype (n): a photographic process usually used to reproduce line drawings or plans

electrochemistry (n): the study of electricity and its relationship to chemical reactions

engraving (n): a print made from an etched metal plate

evolution (n): the process by which the genetic traits of living things change over millions of years

exposure (n): in photography, the length of time a light-sensitive substance is exposed to light

fascicle (n): a portion or installment of a book; a small bundle

fern (n): any of a group of green, flowerless plants with long stems and feathery leaves that reproduce by spores

fixer (n): the chemical solution used to remove unexposed silver in a photographic image and make it stable, also known as hypo

galvanic (adj): related to or producing an electric current

genera (n): (plural of genus) a group of plants or animals more closely related than a family and more broadly related than a species

herbarium (n): a collection of dried plant specimens arranged systematically, usually mounted to paper

hyposulfite of soda (n): a chemical compound (now called sodium thiosulfate) used in photography to dissolve silver salts; the primary chemical in photographic **fixer**

imperialism (n): empire-building; the practice of increasing a nation's power by expanding territorial, political, or economic control

invertebrate (n): an animal that has no backbone

Linnaean system (n.): the classification system of animals and plants designed by the botanist Carl Linnaeus

lithograph (n): a print made from a design drawn or painted on a flat stone

mass production (n): the production of large quantities of goods, usually with the help of machines

mollusk (n): an **invertebrate** with a soft body usually enclosed in a shell

monochromatic (adj): having or using only one color

naturalist (n): a person who studies the natural world

natural philosophy (n): a broad approach to the study of the physical world that combines observation with philosophical thought and predates the modern scientific method

nebulae (n): (plural of nebula) giant clouds of gas and dust in space

negative (n): a photographic image that reproduces dark areas as light and light areas as dark; used to make a second, tonally correct photographic image (positive)

obscurity (n): the state of being relatively unknown or not easily distinguished

panorama (n): an enormous painting viewed in the round, popular in Europe and the United States in the 1800s

photogenic drawing (n): the name William Henry Fox Talbot gave to his first process of making photographs on paper

photogram (n): a photograph made without using a camera by placing objects directly on a light-sensitive material

pigment (n): a colored substance used to give color to other materials

pteridomania (n): a term for the nineteenth-century craze for ferns

specimen (n): a sample collected for scientific study or display

stereoview (n): a pair of nearly identical photographs mounted side by side that form a single three-dimensional image when viewed through a special device called a stereoscope

still life (n): a work of art with a static arrangement of natural and human-made objects

taxonomy (n): the study of naming, describing, and classifying organisms

terrarium (n): an enclosure for growing and observing plants (and sometimes animals)

Victorian (adj): related to the time of the reign of Queen Victoria of England or the typical characteristics or attitudes of that period

zoology (n): the branch of biology that deals with the study of animals

Notes

Introduction

7 "botanical friends": Atkins, *Photographs of British Algae: Cyanotype Impressions*, Introduction.

8 "a lady, some years ago,...": Talbot, "On Photography without the Use of Silver," 495.

8 "Anonymous Amateur": Lang, 702–703.

8 "We leave it to the readers...": ibid., 703.

8 "Mrs. Atkins, who lived...": Britten, 787.

Chapter One: The "A" Is for Anna

13 "handsome, well-built": Hasted, 196–255.

15 "his son should have some employment": Atkins, *A Memoir of J. G. Children, Esq.*, 19.

15 "much admired and much beloved...": ibid.

17 "period of sickness...": ibid., 30.

18 "delicate": ibid., 66.

18 "almost as a daughter": ibid., 267.

18 "dear as a sister": ibid.

19 "severe study": ibid., 73.

19 "greatest galvanic battery": ibid., 156.

20 "very favourite and faithful pug-dog": ibid., 142.

20 "But not long away...": ibid., 142.

21 "her kind governess...": ibid., 135.

22 "his daughter and a few...": ibid., 149.

22 "and almost invariably successful": ibid.

22 "improve [Anna's] understanding...": ibid., 150.

22 "some acquaintance with Natural Philosophy...": ibid.

28 "strong mutual regard and affection": ibid., 203.

34 "sincerely and warmly attached": ibid., 234.

34 "Nothing but the hand of death...": ibid.

Chapter Two: "Impressions of the Plants Themselves"

38 "private houses in the country": Children, "On the Use of a Mixture of Spirit of Wine and Camphine, as a Light for Optical Purposes," 136.

40 "The expensive apparatus...": Murray, iv.

41 "My daughter, Mrs. Atkins,...": Schaaf et al., 56.

42 "It has been proposed...": Feilding.

43 "faithful partner of the last twenty years": Atkins, *A Memoir of J. G. Children, Esq.*, 271.

44 "This led me to reflect...": Talbot, *The Pencil of Nature*, 77.

45 "[T]his is at least the second time...": Feilding.

46 "Your kind Letter followed me...": Children, John George, to William Henry Fox Talbot, September 14, 1841.

48 "Light was my first love": Schaaf et al., 63.

48 "a Teacher and High Priest": Ford, 46.

49 "I have lately taken in hand…": Schaaf et al., 37.

57 "The names refer to…": Atkins, *Photographs of British Algae: Cyanotype Impressions*, Introduction.

57 "Being however unwilling…": ibid.

59 "must lay aside for a time…": Gatty, viii.

59 "to walk where you are walking…": ibid., xi.

63 "The first kind of objects…": Talbot, "Some Account of the Art of Photogenic Drawing," 5.

63 "I feel that the application…": Bird, 189.

64 "greatly aided modern botanists…": Talbot, "Photographic Engravings of Ferns," 569.

64 "The difficulty of making accurate drawings…": Atkins, *Photographs of British Algae: Cyanotype Impressions*, Introduction.

66 "from Mrs. Atkins, with Mr. Children's Kind regards": Atkins, *Photographs of British Algae: Cyanotype Impressions*, bound into the copy formerly in the collection of Sir Thomas Phillipps, now in the collection of the Detroit Institute of Arts.

66 "I have recently had some…": Hunt, Robert, to Sir John Herschel, September 17, 1844.

66 "[Cyanotypes] are so exceedingly simple,…": Hunt, "On the Application of Science," 237.

68 "Mrs. Atkins is much gratified…": Schaaf et al., 56.

69 "Whether the fatigue attendant…": Atkins, *A Memoir of J. G. Children, Esq.*, 305.

69 "Ever since the Great Exhibition…": Hamber, 4.

Chapter Three: The Art of Science

71 "tribute of deep respect…": Atkins, *A Memoir of J. G. Children, Esq.*, Introduction.

71 "the pleasing though mournful labour…": ibid., 312.

71 "I wish you would be kind enough…": Schaaf et al., 73.

72 "I have endeavoured,…": Atkins, *A Memoir of J. G. Children, Esq.*, 312.

73 "Few can understand…": Schaaf et al., 73.

73 "to obtain impressions…": Atkins, *Photographs of British Algae: Cyanotype Impressions*, Introduction.

75 "Should any of the plants…": ibid.

81 "the loveliest scenery of nature…": Newman, xvi.

83 "Your daughters, perhaps,…": Kingsley, 4.

88 "paralysis, rheumatism, and exhaustion": Schaaf et al., 81.

89 "The whole occupation…": Stark, 7.

89 "a profession, a trade,…": Jenkins, 53.

Epilogue

93 "Blueprints are only for plans,…": Emerson, 411.

Bibliography

By Anna Atkins

Anna's original drawings for *Lamarck's Genera of Shells* are housed in the Special Collections of the Natural History Museum, London.

Anna's *Photographs of British Algae: Cyanotype Impressions*, 3 volumes (1843–53) can be found in several museum and library collections. The New York Public Library has fully digitized its copy: https://digitalcollections.nypl.org/collections/photographs-of-british-algae-cyanotype-impressions.

Cyanotypes of British and Foreign Ferns, given by Anne Dixon to Henry Dixon in 1853, is in the collection of the J. Paul Getty Museum, Los Angeles.

Cyanotypes of British and Foreign Ferns, given by Anne Dixon to "C. S. A." in 1853, is in the collection of the National Media Museum, Bradford, England.

A Memoir of J. G. Children, Esq., Including Some Unpublished Poetry by His Father and Himself. Westminster, England: John Bowyer Nichols and Sons, 1853.

The plates from Anna Atkins's album *Cyanotypes of British and Foreign Flowering Plants and Ferns*, given to Anne Dixon in 1854, are widely dispersed, but examples can be found in the collections of the J. Paul Getty Museum, Los Angeles; The Metropolitan Museum of Art, New York; Victoria and Albert Museum, London; and Rijksmuseum, Amsterdam, among others.

Cyanotypes, given by Anne Dixon to Henry Dixon in 1861, is in a private collection.

Selected Works

Allen, David Elliston. *The Victorian Fern Craze: A History of Pteridomania*. London: Hutchinson & Co., 1969.

———. "The Women Members of the Botanical Society of London, 1836–1856." *The British Journal for the History of Science* 13 (November 1980): 240–254.

Armstrong, Carol, and Catherine de Zegher, eds. *Ocean Flowers: Impressions from Nature*. New York: The Drawing Center; Princeton: Princeton University Press, 2004.

Bermingham, Ann. *Learning to Draw: Studies in the Cultural History of a Polite and Useful Art*. New Haven: Paul Mellon Centre for Studies in British Art and Yale University Press, 2000.

Bird, Golding. "Observations on the Application of Heliographic or Photogenic Drawing to, Botanical Purposes; with an Account of an Economic Mode of Preparing the Paper: in a Letter to the Editor of the Magazine of Natural History." *The Magazine of Natural History* 3, no. 28 (April 1839): 188–192.

Britten, James. "A Photographic Bluebook." *British Journal of Photography* 36 (November 29, 1889): 787.

Burns, Nancy Kathryn, and Kristina Wilson. *Cyanotypes: Photography's Blue Period*. Worcester, MA: Worcester Art Museum, 2016.

Children, John George. *Lamarck's Genera of Shells. Translated from the French by J. G. Children, F. R. S., with Plates from Original Drawings by Miss Anna Children*. London, 1823. Originally printed in *The Quarterly Journal of Science, Literature, and the Arts* 14 (October 1822), 15 (April 1823), and 16 (January 1824).

———. "On the Use of a Mixture of Spirit of Wine and Camphine, as a Light for Optical Purposes." *Journal of the Franklin Institute* 44, no. 2 (August 1847): 136–38.

Children, John George, to William Henry Fox Talbot, September 14, 1841. Manuscript Collections, Fox Talbot Collection, British Library, London. The Correspondence of William Henry Fox Talbot online archive (28053): http://foxtalbot.dmu.ac.uk.

Emerson, P. H. *Naturalistic Photography for Students of the Art*. 2nd ed. New York: E. and F. N. Spon, 1890.

Feilding, Elisabeth to William Henry Fox Talbot, February 3, 1839. Manuscript Collections, Fox Talbot Collection, British Library, London. The Correspondence of William Henry Fox Talbot online archive (3788): http//foxtalbot.dmu.ac.uk.

Ford, Colin. *Julia Margaret Cameron: A Critical Biography*. Los Angeles: J. Paul Getty Museum, 2003.

Gatty, Margaret. *British Sea-Weeds. Drawn from Professor Harvey's 'Phycologia Britannica.' with Descriptions, an Amateur's Synopsis, Rules for Laying Out Sea-Weeds, an Order for Arranging Them in the Herbarium, and an Appendix of New Species*. London: Bell and Daldy, 1863.

Gunther, A. E. "John George Children, F. R. S. (1777–1852) of the British Museum. Mineralogist and Reluctant Keeper of Zoology." *Bulletin of the British Museum (Natural History)* 6, no. 4 (June 29, 1978): 75–108.

Hamber, Anthony. *Photography and the 1851 Great Exhibition*. London: Victoria and Albert Museum, 2018.

Harvey, William. *A Manual of the British Algae: Containing Generic and Specific Descriptions of All the Known British Species of Sea-Weeds, and of Confervae, Both Marine and Fresh-Water*. London: John van Voorst, 1841.

Hasted, Edward. "The Lowy of Tunbridge: Tunbridge." In *The History and Topographical Survey of the County of Kent: Volume 5*, 196–255. Canterbury, 1798. http://www.british-history.ac.uk/survey-kent/vol5/.

Herschel, John. "On the Action of the Rays of the Solar Spectrum on Vegetable Colours, and on Some New Photographic Processes." *Philosophical Transactions of the Royal Society* 132 (1842): 181–214.

Hong, Jiang. "Angel in the House, Angel in the Scientific Empire: Women and Colonial Botany during the Eighteenth and Nineteenth Centuries." *Royal Society Notes and Records* 75 (September 2021): 415–438.

Hunt, Robert. "On the Application of Science to the Fine and Useful Arts. Photography—Second Part." *The Art Union* 10 (August 1848): 237.

Hunt, Robert, to Sir John Herschel, September 17, 1844. The Royal Society Archives, London, HS/10/114. https://makingscience.royalsociety.org/items/hs_10_114/letter-from-robert-hunt-to-sir-john-herschel-dated-at-falmouth.

Hunt, Stephen E. "'Free, Bold, Joyous': The Love of Seaweed in Margaret Gatty and Other Mid-Victorian Writers." *Environment and History* 11 (February 2005): 5–34.

Jenkins, Ruth Y. *Reclaiming Myths of Power: Women Writers and the Victorian Spiritual Crisis*. Lewisburg, PA: Bucknell University Press, 1995.

Kingsley, Charles. *Glaucus; or, The Wonders of the Shore*. Cambridge: Macmillan & Co., 1855.

Lang, William, Jr. "A Photographic Bluebook." *British Journal of Photography* 36 (October 25, 1889): 702–703.

Logan, Thad. *The Victorian Parlour: A Cultural Study*. Cambridge: Cambridge University Press, 2001.

Murray, Charlotte. *The British Garden. A Description Catalogue of Hardy Plants, Indigenous, or Cultivated in the Climate of Great-Britain*. Vol. I. Bath: S. Hazard, 1799.

Newman, Edward. *A History of British Ferns*. London: John van Voorst, 1840.

Roos, Anna Marie. *Martin Lister and His Remarkable Daughters: The Art of Science in the Seventeenth Century*. Oxford: Bodleian Library, 2019.

Schaaf, Larry J. "Anna Atkins' Cyanotypes: An Experiment in Photographic Publishing." *History of Photography* 6 (April 1982): 151–172.

———. "The First Photographically Printed and Illustrated Book." *The Papers of the Bibliographical Society of America* 73, no. 2 (1979): 209–224.

———. *Out of the Shadows: Herschel, Talbot and the Invention of Photography*. New Haven: Yale University Press, 1992.

———. *Sun Gardens: Victorian Photograms by Anna Atkins*. New York: Aperture, 1985.

Schaaf, Larry J., et al. *Sun Gardens: Cyanotypes by Anna Atkins*. New York: The New York Public Library and DelMonico/Prestel Books, 2018.

Secord, Anne. "Botany on a Plate: Pleasure and the Power of Pictures in Promoting Early Nineteenth-Century Scientific Knowledge." *Isis* 93 (2002): 28–57.

———. "Pressed into Service: Specimens, Space, and Seeing in Botanical Practice." In *Geographies of Nineteenth-Century Science*, edited by David N. Livingstone, and Charles W. J. Withers, 283–310. Chicago: University of Chicago Press, 2011.

Shteir, Ann B. *Cultivating Women, Cultivating Science: Flora's Daughters and Botany in England, 1760 to 1860*. Baltimore and London: The Johns Hopkins University Press, 1996.

Simons, John. *Goldfish in the Parlour: The Victorian Craze for Marine Life*. Sydney: Sydney University Press, 2023.

Slipp, Naomi, and Maura Coughlin. *A Singularly Marine and Fabulous Produce: The Cultures of Seaweed*. New Bedford, MA: New Bedford Whaling Museum, 2023.

Stark, Myra. Introduction to *Florence Nightingale's Cassandra: An Essay*. Old Westbury, NY: Feminist Press, 1979.

Talbot, William Henry Fox. "On Photography without the Use of Silver." *British Journal of Photography* 9 (December 9, 1864): 494–495.

———. *The Pencil of Nature*. London: Longman, Brown, Green and Longmans, 1844–46.

———. "Photoglyphic Engravings of Ferns." *Transactions of the Botanical Society* (Edinburgh) 7 (June 1863): 568–569.

———. "Some Account of the Art of Photogenic Drawing, or the Process by which Natural Objects May Be Made to Delineate Themselves without the Aid of the Artist's Pencil." Published by the author, 1839.

Ware, Mike. *Cyanotype: The History, Science and Art of Photographic Printing in Prussian Blue*. London and Bradford, England: Science Museum and National Museum of Photography, Film & Television, 1999.

Whittingham, Sarah. *The Victorian Fern Craze*. Oxford: Shire Publications, 2009.

Zucker, Matthew, and Pia Östlund. *Capturing Nature: 150 Years of Nature Printing*. Princeton: Princeton Architectural Press, 2023.

Acknowledgments

My first and greatest debt is to Larry J. Schaaf, whose years of painstaking research unearthed almost everything we know about Anna Atkins. It is thanks to his tireless work that Atkins has been restored to her rightful place in the history of photography. To Larry, for his public contributions and his personal generosity, this attempt is affectionately inscribed. I am also deeply grateful to Dr. Rose Teanby and Hans P. Kraus Jr. for so generously sharing their unparalleled expertise and for their enthusiasm for this project.

It is a thrill to get to introduce a generation of readers to the work of this pioneering photographer, and I am truly thankful to the extraordinary team at Getty Publications for the opportunity. Karen Levine, former editor in chief, first saw the idea's potential and gave me the green light and confidence to pursue it. Publisher Kara Kirk and acting editor in chief Elizabeth Nicholson lent their unstinting support, and assistant editor Darryl Oliver shepherded the project with meticulous attention and good humor. Thanks also to Danielle Brink for coordinating the images and to Dani Grossman for her elegant design that so beautifully sets off Anna's achievements. I am grateful to the three anonymous peer readers whose early feedback enormously enriched the final outcome. I reserve my most profound gratitude for editor Courtney Johnson Thomas, who has not only endured my endless stream of nineteenth-century trivia but has also gently and expertly shaped this text into something worth reading.

I also wish to express my appreciation to the Department of Photographs at the J. Paul Getty Museum, members of Atkins's extended family, and the many institutions and private collectors who have allowed me to reproduce works in their collections and to bring Anna's work and story to life. And to artists Meghann Riepenhoff, Andrea Chung, and the late Francesca Woodman, my profound admiration for their work.

For their scholarly chops and unabashed cheerleading, I thank the members of the Ongoing Moment, with special thanks to Liz Siegel and Sarah Kennel. To my mother, who showed me that writing for young people is harder than it looks and even more rewarding, and to my father, who taught me to make photograms in the darkroom, I give a half century's worth of gratitude. For their uncensored opinions, boundless support, and unconditional love, I dedicate this book to Craig, Zoë, and Theo.

Illustration Credits

Page 1; page 78: Princeton University Art Museum / Art Resource, NY

Page 6; page 12; page 30; page 36; pages 50–54; page 56, top left and bottom right; pages 64–65; page 74: From the New York Public Library / digitalcollections.nypl.org

Page 11: San Francisco Museum of Modern Art, Accessions Committee Fund purchase / Photo: Don Ross

Page 13: Courtesy of the Tonbridge Historical Society, Tonbridge, England

Page 14; page 17; page 89: © National Portrait Gallery, London / Art Resource, NY

Page 15; page 22; page 87: Courtesy of the Nurstead Court Archives

Page 16; page 62, top: Courtesy of the Yale Center for British Art

Page 21; page 39; page 67; page 70: metmuseum.org / CC0

Page 23; page 38: Schaaf, Larry J. with contributions by Joshua Chuang, Emily Walz, and Mike Ware. *Sun Gardens: Cyanotypes by Anna Atkins*. New York: The New York Public Library, 2018.

Page 24: © Royal Collection Enterprises Limited 2024 | Royal Collection Trust

Pages 26–27: Royal Collection Trust / © His Majesty King Charles III, 2025 / Bridgeman Images

Page 29: From the Library and Archives, Natural History Museum, London.

Page 31: University of Reading, Special Collections

Page 33: SSPL / UIG / Bridgeman Images

Page 35; page 43: From the British Library archive / Bridgeman Images

Page 41; pages 60–61: © The Trustees of the Natural History Museum, London

Page 44: Stefano Bianchetti / Bridgeman Images

Page 58: Universitätsbibliothek Heidelberg

Page 59; page 83: © Victoria and Albert Museum, London

Page 62, bottom: Special Collections. Brooklyn Museum Libraries and Archives.

Page 73: Courtesy of the Ferring History Group

Page 77, top right, bottom left, and bottom right: Credit: Hans P. Kraus Jr., New York

Page 79, top left: Stanford University, Cantor Arts Center

Page 79, top right: Wellcome Collection

Page 84: Hibberd, Shirley. *Rustic Adornments for Homes of Taste*. London: Groombridge and Sons, 1856.

Page 86; page 91: The Beinecke Rare Book and Manuscript Library, Yale University

Page 94, left: © Woodman Family Foundation / Artists Rights Society (ARS), New York.

Page 94, right: Image copyright © The Metropolitan Museum of Art. Image source: Art Resource, NY / © Woodman Family Foundation / Artists Rights Society (ARS), New York.

Page 95: © 2017 Meghann Riepenhoff

Page 97: © Andrea Chung

Index

Italic page numbers indicate illustrations.

air quality, 28, 39–40, 58, 84
Albert (prince), 25, 68
albums
 fern, 75–81, 85
 seaweed, *60*, 61–63, *62*
algae, 31, 100. *See also* seaweed
Algae Danmonienses (Wyatt), 61, *61*, 63
algologists, 61, 100
Allom, Elizabeth Anne, 61
amateurs, 19–20, 59, 81, 93, 100
animals, classification of, 28, 31, 101
antiquities, 26, 28, 100
aperture, 43–44, 100
architectural blueprints, 93
asexual reproduction, 59–60, 81, 84
assembly lines, 8–9
astronomy, 39, 48, 67
Atkins, Anna. *See also specific locations, media, and works*
 as A. A., 8–10, 72, 75, 76, 78, 90
 death of, 88
 education of, 21–23, 26
 family of (*See* Children *entries*)
 gaps in knowledge about, 9–10
 legacy of, 90
 marriage of, 33–35 (*See also* Atkins, John Pelly)
 portraits of, *15*, *22*, *87*, 87–88
 writings of, 9
 youth of, 13–26
Atkins, John (father-in-law), 34–35, 37
Atkins, John Pelly (husband)
 death of, 88
 finances of, 34–35, 37
 at Great Exhibition, 69
 introduction to Anna, 23
 on John George's death, 71, 72
 John George's friendship with, 23, 33–34, 37
 marriage to Anna, 33–35
 social network of, 85
Austen, Anne. *See* Dixon, Anne Austen
Austen, Jane, 10, 18, 25
Australia, 42, 75, 85
authors, anonymous, 8–10, 31, 100

Basire, James, *30*
Bath, 37

batteries, 19
Bermuda, 34
Bird, Golding, 63, 64, *64*
Blackwell, Elizabeth, 32
Bleak House (Dickens), 39
Bliss, Sophia, 49
Blueprint for a Temple (1) (Woodman), *94*, 95
blueprints, 93–96
books
 anonymous authors of, 8–10, 31, 100
 disbinding of, 76
 fascicles of, 57–58, 100
 first use of photos in, 7–9, 61–63
botanical gardens, 40
Botanical Society of London, 42–43, 63, 85
botany. *See also* plant(s)
 amateurs' study of, 59, 81
 Anna's place in history of, 10
 colonial specimens in, 33, 34, 42
 defined, 100
 origins of photos in, 61–65
 rise of Anna's passion for, 37, 40–41
 rise of public interest in, 39–40
 women's role in, 40–42, 59–61, 68
British Journal of Photography, 8
British Library, 90
British Museum
 Anna's herbarium in, *41*, 88
 antiquities in, 26, 28
 John George at, 8, 23, 26, 28, 43
 Waterloo elm in, 27
Brontë sisters, 10
Brookes, Samuel, 30
Bullen, Anne (governess), 21–22, 26

calotypes, 46–47, 49, 100
Camden, Lord, 26
camera obscuras, *43*, 43–46, 100
cameras, 46–47, 87. *See also* photography
Cameron, Julia Margaret, 48, *48*, 83
cartes de visite, *87*, 87–88, 100
Catalani, Angelica, 20
The Caterpillar Book (Merian), 32, *32*
Ceylon, 11, 77, *82*
Ceylon (Sri Lanka), 34, 85
Charlotte (queen), 58
chemistry, 19, 22, 44–49
Chester, *23*
childbirth, 17, 18

Children, Anna. *See* Atkins, Anna
Children, Caroline Wise (stepmother), 18
Children, Elizabeth Towers (stepmother), 28, 34, 43
Children, George (grandfather)
 in Anna's childhood, 17–19, 22
 death of, 26, 28
 finances of, 14, 19, 23
 John George's relationship with, 14–15, 19
 marriage of, 14
 portrait of, *14*
Children, Hester Anne Holwell (mother), 13–17, 58–59
Children, John George (father)
 as amateur scientist, 19–20
 in Anna's childhood, 17–19
 Anna's close relationship with, 9, 18, 72
 in Anna's education, 21–23
 Anna's memoir on, 9, 71–72
 at British Museum, 8, 23, 26, 28, 43
 childhood of, 14–15
 death of, 71–72, 88
 education of, 14–15, 17
 finances of, 19, 23–26
 Genera of Shells translated by, 28–33, *29*, *30*, *31*
 at Great Exhibition, 69
 health problems of, 18, 28, 37
 John Pelly's friendship with, 23, 33–34, 37
 on magic lanterns, 38
 marriages of, 15–18, 28, 43
 move to Halstead Place, 43
 move to London, 26
 Photographs of British Algae dedicated to, 49, *52*, 90
 Photographs of British Algae distributed by, 66, 68
 in photography's origins, 45–49
 plans for religious career, 15, 18, 19
 plant-collecting and, 41, 42
 portraits of, *17*, 46
 in Royal Society, 19, 26, 45–46
Children, Susanna (grandmother), 14, 17
Chippendale, Thomas, 27
Chung, Andrea, 96–97, *97*
Church of England, 15
Clark, William A. V., *35*

classes, economic, 25. *See also specific classes*
clothes, 16, 59
coal, 16
cobalt, 96, 100
Codium tomentosum, 72–73, *74*
collecting. *See* specimen collecting
Collen, Henry, 46
colonialism
 in contemporary art, 96
 defined, 100
colonies, British. *See also specific colonies*
 in Industrial Revolution, 16
 specimens from, 33, 34, 42, 81
conchology, 30, 32, 33, *33*, 100
confervae, 49, 100
contemporary art, 93–97
Cooke, F., *13*
Cornwallis, Caroline, 38, 89
cotton, 16
crowdsourcing, 42
Crystal Palace, 69, *69*
A Curious Herbal (Blackwell), 32
cyanotypes. *See also specific works*
 Anna's introduction to technique, 47–49, 63
 in contemporary art, 93–97
 defined, 100
 fading of, 9
 invention of, 7, 47, 47–49, 85
Cyanotypes (1861 album), 85, *86*, 91
Cyanotypes of British and Foreign Ferns (1853 albums), 78–81, *80*, *82*
Cyanotypes of British and Foreign Flowering Plants and Ferns (1854 album), 75–81
 origin of foreign ferns in, 85
 plates from, *11*, *70*, *77*, *78*, *92*
 title page from, *79*
Cystoseira granulata, *6*, 7

Daguerre, Louis-Jacques-Mandé, 43–46
daguerreotypes, 69, *69*, 100
Darwin, Charles, 42
Davy, Humphry, 19, 23, 26, *26*
Devonshire, Duke of, 68, 85
diazotypes, 93, 100
Dickens, Charles, 25, 39, 58
digital cameras, 46
Dillwyn, Mary, 67
disbinding, 76
Disdéri, André Adolphe-Eugène, 87
Dixon, Anne Austen
 Anna's close relationship with, 18, 90
 Cyanotypes by, 85, *86*, 91
 death of, 88
 education of, 22
 fern albums sent to and by, 75–81, 85
 at Great Exhibition, 69
 at Halstead Place, 72, 78
 after John George's death, 72, 81
 marriage of, 43
 photo of, *73*
 in *Photographs of British Algae*, 57, 73, 78
 plant-collecting by, 42
Dixon, Henry (Anne's husband), 43, 69, 72, *73*
Dixon, Henry (Anne's nephew), 78, 79, 85
Dore, Kate, 83, *83*
drawings
 Anna's early, 22, 27, *27*
 in education of women, 32
 of Halstead Place, 37, *38*
 for *Lamarck's Genera of Shells*, *29*, *30*, 30–33, 63
 photogenic, 45, 63, 101
 pros and cons of photos vs., 63–65
 in scientific texts, 31, 32
Duppa, Bryan Edward, *24*

economic classes, 25. *See also specific classes*
economy, 14, 25
Edouart, Auguste, *39*
education, 21–22, 25, 32
electricity, 19, 25, 26
electrochemistry, 19, 100
electromagnetism, 26
Emerson, Peter Henry, 93
engravings, *30*, 30–32, 47, 64, 100
enslaved people. *See* slavery
evolution, 25, 28–30, 100
exposure, 7, 46–47, 100

factories, 16, *16*
fancy work, 83
Faraday, Michael, 26, 45
fascicles, 57–58, 100
Faulkner, Benjamin Rawlinson, *17*
Feilding, Elisabeth, 45, 46
ferns
 Anna and Anne's albums of, 75–81, 85
 defined, 100
 rise in collecting of, 81–85, *84*
Ferox Hall, *13*, 13–23

fixer, 45, 48, 100
fossils, 25, 28, 33
Francis, G. W., 79

galvanic batteries, 19, 100
Ganot, Adolphe, *43*
gardens, 37, 39–40, 84
Gatty, Margaret, 59
gender norms. *See also* women
 in botany, 40–41, 59–60
 in education, 21–22
 in reception of *Photographs of British Algae*, 66
 in social expectations, 8–10, 88–90
 solidification of, 25
Genera of Shells, 28, 30, 33. *See also Lamarck's Genera of Shells*
gentlemen scholars, 19
genus, 28, 100
George III (king), 25, 58
George IV (king), 25
germs, 17, 25
Gifford, Isabella, 61
glass, 84
grasses, 85, *86*
Great Exhibition, 68–69, *69*
Griffiths, Amelia, 61, *61*

Haitian Revolution, 34
Halstead Place
 Anna's drawing of, 37, *38*
 Anna's move into, 35, 37
 Anne's stays at, 72, 78
 burial of Anna and John Pelly at, 88
 family life at, 37–39
 grounds of, 37, 41
 John George's move into, 43
 location of, 37, 60
 servants at, 35, 57
handwriting, 49, *51*, 76, 78–79, *79*
Harvey, William, 57, 61, 63, 64, 65, 73
herbaria
 of Anna, *41*, 41–42, 68, 88
 defined, 41, 101
 seaweed in, 61
Hering, Henry, *89*
hero worship, 88
Herschel, Caroline, 48
Herschel, John F. W.
 coining of term "photography" by, 45
 invention of cyanotype by, 7, 47, 47–49, 64, 85
 and photogenic drawings, 45

Photographs of British Algae
 sent to, 66
 portrait of, *48*
Herschel, Maggie, 47
Herschel, William, 48
Holwell, Hester Anne. *See* Children, Hester Anne Holwell
Hooker, Joseph, *65*
Hooker, William, 41–42, 68
Hunt, Robert, 66–68
hypo (fixer solution), 48, 100
hyposulfite of soda, 48, 101

imperialism, 25, 96, 101
India, 25, 33, 34, 42, 48, 84
Industrial Revolution, 8, 14, 16, *16*, 25, 68
industrialization, 16, 25, 39
invertebrates, 28, 31, 33, 101
Isle of Wight, 22, 25, 60

Jamaica, 34–35, 75, 85
Jardin des Plantes, 66
Jordan, Eliza A., 62
Jordan, J. T., 23, 33
Jordan, Margaret, 23

Kent. *See* Halstead Place; Tunbridge
Kew Gardens, 40, 68, 90
Kingsley, Charles, 83

Lamarck, Jean-Baptiste, 28, 66
Lamarck's Genera of Shells, 29, *30*, *31*, 63
Lang, William, Jr., 8, 10, 68, 90
Latin language, 22. *See also* plant names
Lee, Frederick Richard, 59
Leech, John, *58*
Leicester Square, 20, *21*
letters, 9–10, 89
Linnaean system, 28, 31, 60, 101
Linnaeus, Carl, 28, 32
Linnean Society, 66, 67, 90
lionfish, 97
Lister, Anna, 32
Lister, Martin, 32
Lister, Susanna, 32
lithographs, 22, *38*, 101
Llewelyn, John Dillwyn, 67, *67*
Llewelyn, Thereza Mary Dillwyn, 67, *67*
London. *See also specific locations*
 Children family living in, 26, 28
 Children family visits to, 20–21, 40
 Great Exhibition in, 68–69, *69*
 population of, 39

magic lanterns, 38, *39*
A Manual of the British Algae (Harvey), 57, 61, 63, 64, 65, 73
mass production, 16, 39, 88, 101
Mayall, John Jabez Edwin, *69*
medical advances, 25
A Memoir of J. G. Children, Esq., (Anna Atkins), 9, 17, 71–72
men in science. *See also* gender norms
 amateur, 19–20, 59
 plants ignored by, 59, 81
 role in botany, 41
 women family members of, 10, 18, 23, 31, 42, 67
Merian, Dorothea, 32
Merian, Johanna, 32
Merian, Maria Sibylla, 32, *32*
microscopes, 32, 39, 41, 42, 47, 67
middle class, 16, 25, 58, 84
Moffat, John, *44*
mollusks, 28, 31, 101
monochromatic art, 65, 101
Murray, Charlotte, 40

Napoleon, 20, 25, 27
Natural History Museum, 88
natural philosophy, 19, 22, 101
naturalists, 39, 101
nature, rise of public interest in, 39–41
nebulae, 48, 101
negatives, 46, 48, 85, 101
networks. *See* social networks
Newman, Edward, 81
Nightingale, Florence, 89, *89*
novels, 9, 10, 25, 57–58
nursing, 89

obscurity, 8, 101
Oliver, Archer James, *14*

panoramas, 20, *21*, 101
Papaver rhoeas, 86, *91*
paper, Whatman, 78
Paxton, Joseph, 68
peacock feathers, 85, *86*
pen names, 10
The Pencil of Nature (Talbot), 8–9, 66
Philosophical Society of Glasgow, 8
photogenic drawings, 45, 63, 101
photograms, 45, 101. *See also* cyanotypes
Photographic Society, 25
Photographs of British Algae: Cyanotype Impressions (Anna Atkins)
 A. A. as author of, 8–10, 90
 Anne's role in, 57, 73, 78

 completion of first section, 7, 49
 completion of second volume, 68, 71
 completion of third volume, 72–75
 dedication to father in, 49, *52*, 90
 distribution of, 7, 8, 9, 57–58, 66–68, 73
 innovative nature of, 7–9, 61–63, 66–68, 90
 introduction to, *51*, 57, 64
 Lamarck's Genera of Shells as preparation for, 30–33, 63
 Lang's search for, 8, 10, 68, 90
 Latin names in, 49, 57, 81
 number of copies made, 9, 66
 plate corrections and replacements for, 58, 73–75
 plates from Volume I of, *6*, *12*, *36*, *53–56*
 plates from Volume III of, *74*
 plates republished in *Cyanotypes*, 85
 process of making book, 8–9, 49, 57–58
 process of making cyanotypes, 7, 49, 57
 reception and reviews of, 66–68
 social network in, 42, 57
 start of work on, 49
 title pages of, 49, *50*, 63, *63*, 76
photography. *See also specific subjects and types*
 Anna's place in history of, 8–9, 10, 49, 68, 90
 chemicals in, 19, 44–49
 coining and use of term, 45, 48
 fading of prints in, 9, 47, 48, 49
 first use in books, 7–9, 61–63
 at Great Exhibition, 69
 invention of, 8, 44–49
 pros and cons of drawing vs., 63–65
 royal use of, 25
The Pickwick Papers (Dickens), 58
pigments, 49, 101
plant(s). *See also* botany
 classification of, 28, 31, 60, 101
 from colonies, 34, 42, 81
 reproduction in, 59–60, 81, 84
 women collecting, 40–42
plant names, Latin
 in Anna's herbarium, 41
 in *A Curious Herbal*, 32
 in *Cyanotypes*, 85
 in fern albums, 75, 81
 in *Photographs of British Algae*, 49, 57, 81
 women's knowledge of, 22, 41
poetry, 14, 20, 47, 71

polite activities, 40–41
positives, 46, 48
Pratt, Anne, 61
Pride and Prejudice (Austen), 10, 25
Prussian blue, 49
pteridomania, 83, 101

Quakers, 34
The Quarterly Journal of Science,
 30–31

railroads, 16, 25, 35, 40, 68
Regency period, 25
Rejlander, O. G., *83*
religion
 in Anna's education, 22
 and evolution, 30
 John George's plans for career in, 15,
 18, 19
Riepenhoff, Meghann, *95*, 95–97
Ross, Andrew, 46–47
Rowlandson, Thomas, *26*
Royal Institution, 26, *26*, 45
Royal Society
 Herschel in, 48
 John George in, 19, 26, 45–46
 Photographs of British Algae
 sent to, 66
 Talbot in, 44–46

science. *See also specific fields*
 advances in Victorian era, 25
 amateurs' role in, 19–20, 59, 81
 illustrations in texts on, 31, 32
 Latin in, 22
 professionalization of, 19–20, 48
scientific method, 20
scientific specimens. *See* specimens
scientists, origin of term, 20. *See also*
 men in science; women in science
Scotland, 8, 81, 85
seashells. *See* shells
seaweed. *See also Photographs of*
 British Algae: Cyanotype
 Impressions
 albums of, *60*, 61–63, *62*
 classification of, 31, 60
 manuals on, 57, *61*, 61–65, *62*
 reproduction in, 59–60, 81
 rise in collecting of, 33, *58–60*,
 58–61
 women's role in study of,
 58–61
Sense and Sensibility (Austen), 10
sexism, 68

shells
 in *Lamarck's Genera of Shells*,
 28–33, *29*, *30*, *31*, 63
 rise in collecting of, 33
 study of (conchology), 30,
 32, 33, 100
slavery, 25, 34–35, *35*
social networks
 of Anna, 42, 57, 75, 85, 90
 of John George, 23, 47, 66
species, 28
specimen, defined, 101
specimen-collecting
 in colonies, 33, 34, 42, 81
 of ferns, 81–85, *84*
 of seaweed, 33, *58–60*,
 58–61
 of shells, 33
 women's participation in science
 through, 33, 40–42, 68
Spratt, George, *33*
stereoviews, 69, 101
still lifes, 47, 101

Talbot, Constance, 45
Talbot, William Henry Fox
 botanical photos of, 63–64, 65
 on Great Exhibition, 69
 in invention of photography, 8,
 44–49
 letters of, 9
 Llewelyn family and, 67
 The Pencil of Nature, 8–9, 66
 and *Photographs of British*
 Algae, 8, 66, 90
 portrait of, *44*
taxidermy, 39
taxonomy, 28, 101
tea, 84
telescopes, 39, 47, 67
terrariums, 39, 101
Towers, Elizabeth. *See*
 Children, Elizabeth
Tunbridge (Tonbridge)
 economy of, 14
 Ferox Hall in, *13*, 13–23
 George's funeral in, 26
 Tunbridge Bank in, 23, 26

Ulva latissima, 72–73, *74*
United States, 34, 75, 85
Untitled (Woodman), *94*, 95
upper class, 17, 21, 25, 84

Victoria (queen), *24*, 25, 35, 40,
 63, 69, 88
Victorian era, 9, 25, 101. *See also*
 specific aspects of life
Vitoria, Battle of, 20
Volta, Alessandro, 19
voting rights, 25

Ward, Nathaniel Bagshaw, 84
Wardian cases, 81, 83, *84*
water, in cyanotype process,
 7, 49, 57, 60, 73, 93, 96
watercolor paintings, 22, *23*, 30
Waterloo, Battle of, 27
The Waterloo Elm (Children), 27, *27*
Wellington, Duke of, 20, 27
Whatman paper, 78
Wise, Caroline. *See* Children, Caroline
women
 as anonymous authors, 8–10, 31, 100
 dangers of childbirth for, 17, 18
 education of, 21–22, 32
 fern-collecting by, 81–85
 gaps in history of, 8–10, 88–90
 plant-collecting by, 40–42
 private lives of, 9, 88–90
 seaweed-collecting by, 33,
 58–61, *60*, *61*
 shell-collecting by, 33
 social expectations for, 8–10,
 88–90
 voting rights for, 25
 work outside the home by, 89
women in science
 illustrations by, 31, 32
 role in botany, 40–42, 59–61, 68
 scientific men in families of, 10, 18,
 23, 31, 42, 67
 social networks of, 42, 90
 social norms against, 10, 90
 specimen-collecting by, 33,
 40–42, 68
Woodman, Francesca, 93–95,
 94, 97
working class, 25
Wyatt, Mary, 61, *61*, 63

zoology, 28, 34, 101

© 2025 J. Paul Getty Trust

Published by Getty Publications, Los Angeles
1200 Getty Center Drive, Suite 500
Los Angeles, California 90049-1682
getty.edu/publications

Darryl Oliver and Elizabeth S. G. Nicholson, *Project Editors*
Courtney Johnson Thomas, *Manuscript Editor*
Dani Grossman, *Designer*
Molly McGeehan, *Production*
Danielle Brink, *Image and Rights Acquisition*

Distributed in North America by ABRAMS, New York

Distributed outside North America by
Yale University Press, London

Printed in China

Pages 98-99: *Ulva latissima* from *Photographs of British Algae: Cyanotype Impressions* (Vol. III) by Anna Atkins, 1853 (page 74, detail)

Back cover, left: *Himanthalia lorea* from *Photographs of British Algae: Cyanotype Impressions* (Vol. I) by Anna Atkins, 1843 (page 12)

Back cover, right: *Cypripedium (Portland U.S.)* from *Cyanotypes of British and Foreign Flowering Plants and Ferns* by Anna Atkins, 1854 (page 92)

Library of Congress Cataloging-in-Publication Data

Names: Keller, Corey author
Title: Anna Atkins : photographer, naturalist, innovator / Corey Keller.
Description: Los Angeles : Getty Publications, [2025] | Includes bibliographical references and index. | Audience: Ages 13-18 | Audience: Grades 7-9 | Summary: "Explore the life of Anna Atkins, the pioneering photographer who combined art and science to create the first photographically illustrated book"-- Provided by publisher.
Identifiers: LCCN 2025004343 (print) | LCCN 2025004344 (ebook) | ISBN 9781947440111 hardcover | ISBN 9781606069844 epub
Subjects: LCSH: Atkins, Anna, 1799-1871--Juvenile literature | Photographers--Great Britain--Biography--Juvenile literature | Cyanotypes--History--19th century--Juvenile literature | Photography--England--History--19th century--Juvenile literature | BISAC: YOUNG ADULT NONFICTION / Biography & Autobiography / Art | YOUNG ADULT NONFICTION / Photography | LCGFT: Biographies
Classification: LCC TR140.A8175 .K45 2025 (print) | LCC TR140.A8175 (ebook) | DDC 770.92/241--dc23/eng/20250428
LC record available at https://lccn.loc.gov/2025004343
LC ebook record available at https://lccn.loc.gov/2025004344

The complete manuscript of this work was peer reviewed through a single-masked process in which the reviewers remained anonymous.

Authorized Product Safety Representative in the European Union: Easy Access System Europe, Mustamäe tee 50, 10621 Tallinn, Estonia, gpsr.requests@easproject.com

Illustration Credits
Every effort has been made to contact the owners and photographers of illustrations reproduced here whose names do not appear in the captions or in the illustration credits listed on p. 107. Anyone having further information concerning copyright holders is asked to contact Getty Publications so this information can be included in future printings.

FSC — MIX Paper | Supporting responsible forestry — FSC® C008047